T0197353

MY SCRAWLS AND Scribbles

LO SIN YEE

For book orders, email orders@traffordpublishing.com.sg

Most Trafford Singapore titles are also available at major online book retailers.

Printed in Singapore.

ISBN: 978-1-4669-3502-0 (sc)
ISBN: 978-1-4669-3517-4 (hc)
ISBN: 978-1-4669-3518-1 (e)

Trafford rev. 07/26/2013

 www.traffordpublishing.com.sg

Singapore
toll-free: 800 101 2656 (Singapore)
Fax: 800 101 2656 (Singapore)

Contents

1. Found . 1

2. Exhibitionist Boy . 9

3. The Girl in His Dreams. 14

4. Reclaiming The Past . 23

5. Suicide . 32

6. We Are All the Same . 41

7. Two Hundred and Fifty Buns 48

8. No Escape from Fire-Sterilized Injection 54

9. Being Hazed at The Teacher Training College 60

10. Lesson from My First Day As A Teacher 78

11. "Shit!" . 93

12. Lost in Hangzhou . 96

13. My Struggle with Panic Attacks. 100

14. Reading. 106

15. Advanced Vocabulary . 109

16. Madam Sheila . 111

17. A Visit to The Bangkita Tamu in Limbang 113

18. Pak Pandir. 123

19. Stereotypes . 127

20. Papa, You Are My Everything 130

21. Dictionaries. 134

22. Acknowledgements . 137

Found

The crowds at the Sunday bazaar begin to thin away with the decline of the sun towards the upper end of the riverside town. Kassim has just finished eating the rice given by Mak Minah, a generous lady who runs an economy rice stall at the bazaar. Licking the leftover gravy off his lips, he sits on a curb beside the bus stand and looks intently at the slowed-down transactions between vendors and customers. The vendors begin to pack up their stalls, while the customers are in haste to go home. He never comes to the bazaar when it is thick with people. He makes his usual appearance at the bazaar around five o'clock in the evening, always sitting in the same spot, biding his time and waiting for an opportunity to collect unsold, wilted vegetables.

"Come over here, Pakcik[1], I have some vegetables for you!" a Chinese vendor named Wong hollers while beckoning him over with a wave of the hand. A grateful smile is etched on Kassim's sagging, wrinkled face. He props himself up on his walking stick and rises from the cold concrete stone of the curb. He

[1] Malay language: Uncle

struggles for balance because the long sitting has given him pins and needles in his legs. Taking a deep, raspy breath, he adjusts the tilted songkok on his skeletal head and staggers in Wong's direction. The cramp, tingling sensation gradually subsides with each dragging movement of his feet.

When Kassim reaches Wong's van, the tall, pot-bellied vendor asks him to open his dirty sling bag and shoves two rust-coloured cabbages into it. Kassim, whose voice is hoarse, says thank-you. He turns on his heel and walks deeper into the market, against the homeward flow of people. His shadow trails long behind him in the dimming, ochreous light. Something catches his eye, and he bends down to pick up three stray bananas from the rubbish-strewn ground. He puts them into his bag and resumes walking.

He makes an obligatory stop at the rubbish dump of the bazaar. There are a few skinny, mangy cats in the dump gnawing barbequed-chicken bones with ravenous relish. They scurry off in a freak of timidity at the sight of Kassim. The old man smiles bitterly to himself. *Don't they know that I am like them, too?* He bends over and starts combing through the rubbish for empty tins and bottles—he earns a pittance by sending them to recycling centres. Kassim has grown immune to the overpowering stench. Halfway through the search, he hears two people talking several metres behind him.

"Mama, what is that old man doing in the rubbish dump?"

"He's looking for food."

"How dirty he is."

"If you don't study hard, you may end up like him."

"I don't want to, Mama!"

"You should study hard from now on. Read as many books as you can."

"Mama, reading books is so boring. I'd rather read comics."

"Boring? Laziness will make you become like that dirty man!"

"I am not dirty, Mama!"

"Because I make you clean."

Kassim can feel the weight of their stares on his back. He looks over his shoulder and sees a woman about forty years old and a boy who cannot be more than eight or nine. They are sizing him up with covert sneers on their faces. Their conversation comes to a halt when Kassim's eyes meet theirs. The woman looks away in uneasiness. She whispers something to her son, and without looking back, they hurry off in the direction of the car park. Kassim envies them a great deal. They have each other, but he has no one other than himself.

By the time Kassim calls his scavenging a day, the last vestiges of twilight have faded, and the whole town looks like a picture blotted in with ink. His bag is bulging with the empty cans and bottles. With a sigh, he retraces his way back to the bus stand. His feet shuffle amid the waxing and waning sounds of pushcart wheels. The buzz of voices around him is wearing off. Streetlight halos illuminate the dark streets. Vehicles roar past him, sending gusts of wind into his face. He blinks away the dust, clears his throat, and spits a glob of phlegm into the grass verge that borders the road.

When he reaches the bus stand, he feels as if his frame of bones is dismantling into a heap. He is dog-tired. He wants to lie down and sleep on the straw mat in his house. If possible, he doesn't want to wake up. He is tired of his long life. Sometimes, he cannot help wondering whether God and His angels have lost track of his soul. He is wasting his life as one of the living dead on earth.

Suddenly, he catches sight of two men across the road. Their faces are not visible in the faint lamplight, but Kassim can tell from the size of their bodies that they are tall and well-built. It is not the first time Kassim has seen them. He saw them in the same spot several times over the past four weeks. He has a strange feeling that they are looking at him. *Who are they? What are they up to? Can others at the bus stand see them, too?* He can feel his skin crawling.

Kassim heaves a sigh of relief when a bus trundles into view on the shoulder of the road. It rumbles to a halt beside the bus stand and disgorges a stream of passengers. And then everyone at the bus stand piles into the bus, ignoring the poor old man who is too weak to join in the frenzied rush. It takes Kassim a great deal of effort to board the bus. His slowness is frowned upon by the driver who almost barks profanities at him. After exerting himself, he launches into a coughing fit. Some cheeky youths sitting at the back parody the way he coughs and burst out laughing. He shakes his head in disapproval. His blood would have boiled with anger had he been younger. Old age has softened his emotion. He scans his myopic eyes over the heads in the compartment and finds an unoccupied seat next to a young Malay girl. He dares not sit beside her. He knows how stinky and dirty he is. He grabs hold of the overhead rail with his fingers and tries to keep his footing in the shake and sway of the bus.

Suddenly, he hears a gasp from the girl. She gets up from her seat and edges towards him. She grabs his left arm with one hand and puts the other on his back as she gently brings him to her seat. He wants to say no, but the sincere smile on her face makes him yield to her will. Once he is seated, he thanks her.

"Are you feeling better now, Pakcik?" asks the girl.

"I—I'm all right," stammers Kassim, still half-dazed by the unexpected gesture.

"Where is your house, Pakcik?" asks the girl, who reminds him of Faridah, pretty and kind-hearted. They have the same eyes, too.

"I live in Simpang Tiga," replies the old man, his voice quavering. He is ashamed at how he looks.

"Simpang Tiga is quite far from the bazaar!" replies the girl, her voice tinged with surprise. "Why don't you ask your family members to take you there?"

"I have no family," says Kassim, embarrassed. His wife Faridah died of miscarriage nearly fifty years ago. Dirt poor, he lives on the monthly subsistence allowance given by the welfare department.

"I'm sorry, Pakcik," says the girl, and gives him a sympathetic look.

"It's okay, I am used to it." Kassim's voice falters. He is touched by the girl's empathy. She does not show any negative feelings towards him.

"Hari Raya ²is drawing near. Will you be celebrating it with your relatives?"

"No, I have no relatives," replies Kassim.

"Poor Pakcik," sighs the girl. "You must be very lonely."

Kassim opens his mouth to reply, but he chokes on his words. He turns his face away from her, trying to hide his teary eyes. But the girl grabs hold of his hands and says, "Don't worry, Pakcik, your loneliness will soon be over."

Kassim is startled, puzzled by what she means.

² Eid celebration

The girl seems to know what he is thinking. She smiles and says, "We've found you, and soon you will be with us."

Kassim feels even more confused. He wants to ask who she is referring to, but the eyes of the girl have a strange effect in quelling his urge.

The girl looks out the window and says, "Pakcik, we've almost reached your house. Am I correct? Let me press the bell for you."

Kassim nods, grateful for all that she has done for him. He watches her rise and press the bell.

The bus grinds to a halt. Kassim thanks the girl in a muffled voice and alights the bus, taking his doubts along with him.

Kassim's wooden house stands back twenty yards from the main road, half-buried in a copse of trees. The shrill droning of cicadas accompanies him as he walks along the trail to his house. The house exudes an aura of loneliness. But it is his, his own home, passed down by his family. Moonlight filters through the overhead layers of branches and leaves, giving some brightness to the dark surroundings.

When Kassim reaches the facade of his now decrepit house, he sees two dark shadows flitting past him. He looks all around him, sure that they are the men opposite the bus stop. They seem to be following him everywhere. He closes his eyes and opens them again. There is no one in sight. *Are my eyes playing tricks on me?* He shrugs and walks up the steps. He produces his key from his trouser pocket and inserts it into the rusty lock of the front door. After some twisting, the door finally opens. He steps inside. As usual, he fumbles for the light switch in the dark. When he locates it, he switches it on. The fluorescent tube on the ceiling blinks blue and orange before becoming steadily bright. Just as he is about to drop his bag on the floor, he has a

sudden bout of heart palpitations. The rafters above him spin, and his legs buckle under him. Holding his chest in agony, he sinks to his knees. A cold, stinging sensation pulsates through his arms, and his breathing becomes jagged. Through his ringing ears, he seems to hear the creaking of loose floorboards coming his way. Before he knows what is happening, two warm hands circle around his shoulders, and a gentle voice whispers into his ear, "Welcome home, Kassim."

Gasping in shock, Kassim finds himself kneeling face-to-face with Faridah. She looks surprisingly youthful and beautiful. He can smell her sweet fragrance of plumeria. She seems real, very real. His heartbeat slows down to a normal pace, and a torrent of energy washes over him. He feels like he is young again.

"Faridah!" Kassim cries, hugging her tightly. "It's you! You've finally come back to me."

"My heart is always with you, Kassim," replies Faridah in a calm, soothing voice.

"I have wanted to see you very much," says Kassim. "God has finally granted my wish."

"God is always good to us," says Faridah, kissing Kassim's cheek. "He always knows when is the best time for us to reunite."

"Am I dreaming?" Kassim asks, looking at Faridah's shimmering face and seeking assurance from her.

"No, you are not," says Faridah. "We were predestined to meet each other today."

Kassim's eyes are brimming with tears. He does not want to let go of Faridah this time. He loves her to the last fibre of his being.

Noiselessly, two hands rest on Kassim's shoulders.

Kassim looks up and sees the girl he met on the bus.

Faridah puts her hand on the girl's shoulder and says, "Kassim, she is our daughter, Hapsah."

"Hapsah? Our daughter?" murmurs Kassim, turning to look at Faridah with a questioning gaze.

"Yes, Kassim," replies Faridah, nodding.

Bending over, Hapsah takes hold of Kassim's hands and brings them to her forehead. Again she says, "We have found you." Tears of gratefulness roll down Kassim's cheeks as he puts his hand on Hapsah's shoulders and the other on Faridah's.

Two dark shadows glide into the house through the open door. They become brighter and brighter as they inch towards the hugging trio. Soon, the room becomes blinding with the light that they radiate. It engulfs Kassim, Faridah, and Hapsah until they are seen no more.

The following day, two social workers go to Kassim's house. Since Hari Raya is just around the corner, they are bringing him rice and some new clothes. They are shocked to find the door ajar and Kassim lying unconscious on the floor, with a look of contentment on his face.

Exhibitionist Boy

It's sports day at Thye's school, and break time is almost over. In a few minutes, the 1,500 metre race will begin. Every athlete and teacher on duty will have to swelter in the heat along the stadium track. As Thye walks down the steps of the grandstand and heads in the direction of the washroom, he receives a phone call from his principal.

"Mr Thye, I want you to come over to the security office at Bintang Plaza now," commands the principal in a grave tone.

"Yes, but may I know what is happening?" asks Thye, perplexed by the timing since the race is about to start.

"Your student, Christopher, was caught exposing his genitals to a female sales assistant."

"What!?" Thye exclaims in disbelief. Christopher is a shy, soft-spoken boy who transferred to Thye's school from Bintulu three weeks ago. Thye finds it difficult to associate the boy with the perverted deed. He is also baffled as to why Christopher is at the shopping mall. He should be at the stadium by now. Break time is almost over.

When Thye casts doubt upon the validity of what has been said, the principal asks him not to waste any time.

"Come to Bintang Mall as soon as possible," he says. He is unusually impatient and gruff in tone, giving Thye the distinct impression that the principal will bark at him if he dares to ask any more questions. He asks a colleague, Mr Juan, to take him to Bintang Plaza in his Proton Wira so he would have someone level-headed to talk the matter over with.

When they reach the security office in the basement car park of the mall, they see the alleged exhibitionist, Christopher, standing with his head down. He is with a security guard, a young woman, and the principal. The security guard is a dark-skinned man in his late forties, and the female is a fair-skinned Kenyah woman in her early twenties. Judging from her angry look, she must be the sales assistant whom the boy has allegedly harassed. She is wearing a light pink tank top with a deep cut V-neck that shows the silky white flesh of her cleavage. Her hot pants reveal her shapely thighs. Mr. Juan and he are thinking the same thing: *What a curvaceous woman.*

Upon seeing Thye, the principal says, "Encik Mansyor, this is Mr Thye, the boy's form teacher."

"Mr Thye, I am Encik Mansyor," says the security guard, extending his hand to shake Thye's. "And this is Linda, the intended victim."

Thye and Mr. Juan both nod politely to the young woman, their gaze lingers on her body curves and her cleavage in particular.

Encik Mansyor then turns to Christopher and says, "Okay, boy. You said that your form teacher could vouch for your innocence. Tell him what actually happened now!"

The boy says nothing, but his chest heaves with emotion.

"Yeah, Christopher, what happened?" Thye asks as he taps the boy's shoulder.

The boy looks up at Thye and says, "Mr Thye, it was a misunderstanding. I would never do such a thing."

"What are you talking about!?" hisses Linda.

"It's true. You misunderstood me," Christopher says in defence, his voice choking with emotion.

"How did I misunderstand you?" the woman demands to know. She raises her voice as she speaks and shoots a condemning glare at the boy. "Who was it that unzipped his fly and fished out his penis in front of me? Or did I just imagine that it happened?"

"Yes, that's it. You imagined it happened."

"How dare you lie like that! I saw what you did and you know exactly what you did, you pervert!"

Seeing that the woman is losing her self-control, the principal asks her to calm down and explains to Thye that Christopher was caught exposing his genitals to the young woman while window-shopping at the unisex boutique where she works.

"I happened to be outside the boutique when Linda screamed," Encik Mansyor recalls. "I rushed in and caught hold of the boy. She told me that he had unzipped himself in front of her."

"I . . . I did not do it," interrupts the thirteen-year-old, bespectacled boy. "Something happened to my belt. Its buckle came loose, and I was trying to pull my jeans up."

"Did your belt buckle really come loose?" Mr Juan asks.

The boy nods meekly.

"Don't listen to him. He is lying," the woman says through gritted teeth, pointing an accusing finger at the boy.

"Christopher," says the stern-looking principal, "pull up your shirt. Let me see your belt."

The boy hesitates, his face turning paler and paler.

"Show me your belt!" repeats the principal.

Reluctantly, the boy lifts the lower hem of his shirt. Everyone's eyes focus on the belt loops on the waistband of his trousers.

"You are lying!" declares the principal. "You aren't even wearing a belt!"

"I was," insists the boy, "but I left it in the boutique."

"Your jeans do not slip down without the belt," Mr Juan says, pulling the waistband of the boy's jeans to test its tightness. "They seem to fit quite well."

"As far as I can remember," says the security guard, "you never pulled out your belt in the boutique."

"No use telling us such a blatant lie!" snaps Linda.

"Do you want me to phone your parents?" threatens the principal.

"No, no! Don't phone my parents!" the boy begs loudly.

Thye's mind is totally blank now. He looks sideways at Mr Juan. Their eyes lock in tacit agreement that nothing can be done to defend the boy. Mr. Juan looks at Linda, too. He nods as if to suggest that he sympathizes with the young woman.

After more pressure from both the principal and Encik Mansyor, Christopher finally admits to having exposed his private parts to the sales assistant. He signs a document promising that he will never commit such an indecenct act again. To Thye's immense relief, the sales assistant accepts his apology. Before they leave, Mr. Juan approaches Linda, says a few words to her and offers his card.

Thye, Mr Juan, the principal, and Christopher are now standing outside the shopping mall.

"Mr Thye, you can return to the stadium with Mr Choo," says the principal. "I will take Christopher back to his house."

"Yes, sir," Thye replies with a nod.

Just as Thye is about to enter Mr Juan's car. Christopher tugs at his shirt and says, "Teacher, please believe me! I am innocent!"

Shocked, Thye asks him what made him own up in the security room.

"Mr Thye, I had no choice. None of you believed anything I was saying!" he replies, breaking down in tears.

"Come! Get into the car!" the principal snaps as he bundles the snivelling boy into his car and drives off.

Thye remains rooted to the spot where he stands until the car disappears into the distance. He then asks Mr. Juan why he is smiling.

"Do you agree that the whole thing was a blessing indisguise?" said Mr. Juan. "I did manage to get a date."

"Yeah, and we did escape the heat from not umpiring the 1500 race," Thye adds. "But now I wonder why the boy transferred here in the first place. Was he caught doing the same thing? Perhaps I could find out."

"Perhaps," says Mr. Juan, still thinking about his date. "Perhaps we could go to a movie."

"A movie?"

"Yes, I could take Linda to a movie, someplace where it is nice and dark. Did you get a good look at her? Wow! No wonder the boy went ga-ga."

Thye gives Mr. Juan a look of rebuke, but then he chuckles along with Mr. Juan over his joke.

"I never expected the boy to do such a thing," Mr. Juan says. "But we should thank him for doing us such a favour today."

Thye falls quiet. He is thinking about what Christopher's parents will do once they find out that their son is an exhibitionist. *Thank God he is just a child. If he were an adult, he could be sent to jail.*

The Girl in His Dreams

Wu Fang had a strange recurring dream before he attended the literature workshop at the Teacher Activity Centre along Bintang Road.

In the dream, he reached his home in Pin Fook Garden after school one evening. The moment he crossed the threshold of his house, a young woman in a crushed-flower dress greeted him. The woman had an oval face, plain but pleasing to look at. Her slanted eyes were matched by a well-defined nose and delicate lips. Her hair, tied into a ponytail, was parted down the centre. She exuded a nurturing kindness that comforted him as she gave him a hug. Wu Fang surprised himself by putting his arms around her and kissing her cheek. He did not know who she was, but found himself drawn to the warmth of her touch and the light floral scent emanating from her slim body.

He then heard children's voices ringing around them, and the two of them were surrounded by three kids ranging from six to eight years old. He found himself stroking the soft hair of their heads and lifting up a girl in his arms. A soft, fuzzy light

moved like an undulating stream around them, and his heart was flooded by an overwhelming sense of peace.

Wu Fang always laughs off the dream as something daft and illogical. He has never thought of himself as suited to marriage. A regular psychiatric outpatient—a borderline schizophrenic, as his doctor called him—he cloisters his heart with impregnable walls of reserve. It is not easy for others to penetrate his inner world.

Wu Fang is fifteen minutes late for the first day of the literature workshop. Organized by the Ministry of Education, it is held for three days to train selected teachers how to teach literature creatively. Wu Fang wanted to be punctual for it, but a stomach upset delayed him. After apologizing to the speaker of the workshop, he takes an empty seat beside a young woman. She turns her head in his direction and greets him. Wu Fang is stunned at the sight of her face. He cannot believe his eyes. This is the woman who appeared repeatedly in his dreams. Are his eyes playing tricks on him? No, she is dressed in the same crushed-flower dress that she wore in his dreams. For a moment, Wu Fang is lost in her smiling eyes. The world has become still and quiet between them. They are standing face-to-face on a path overhung with trees. Light and shade play around them. Birds are chirping, and the sweet scent of morning dew is in the air. What is happening? Is he dreaming again? A warm, mellow sensation pulsates through the veins of his whole being. Is it what love feels like?

Wu Fang quickly collects himself and returns her greeting. She introduces herself as Brenda Chong, a teacher in a rural school.

"I am happy to meet you," Wu Fang says, trying to smooth out his stammering voice.

"Me too," Brenda replies.

"I've never seen you in the workshops I've attended before," Wu Fang says. "Are you a newly posted teacher?"

"Yes, I am," says Brenda. "It's my second year of teaching. How long have you been teaching?"

"Fourteen years," Wu Fang answers.

"You must be very experienced," Brenda says.

"No, not really," says Wu Fang, a little uneasy about the age difference between them.

Their conversation is interrupted by an announcement.

"Good morning, ladies and gentlemen," says the speaker, an Indian lady in her late forties. "We are going to start today's workshop with an ice-breaking activity. Get into pairs, and we will give each of you a piece of paper. You are to stick it on your partner's back."

Her male assistant picks up a stack of papers from the desk and distributes them among the participants. All the teachers do what the speaker asked them to do.

"Ladies and gentlemen, please move to the centre of the room," continues the Indian speaker. "Walk around and write a suitable adjective on everyone's back. Avoid repeating the same adjective."

Chuckles ripple through the teachers. A Malay teacher sets the activity in motion by writing an adjective on a Bidayuh teacher's back. Everyone follows suit. Wu Fang feels his blood rushing to his face as Brenda writes on his back. When Brenda turns her back to him, he hesitates and is at a loss for what to write.

"Hey," Brenda asks, "why are you not writing on my back?"

"Sorry," Wu Fang says, "my pen has run out of ink."

"Use mine, then," says Brenda, unsuspicious of Wu Fang's lie.

Wu Fang takes Brenda's pen and scribbles the word *friendly* on her back. He had a strong impulse to write *beautiful* but thought better of it. And then they both weave through the crowd of teacher participants, labelling their backs with the best adjectives. Throughout the activity, Wu Fang observes Brenda on the sly. Unlike him, she has no problem mingling with the others. She pays attention to what people are saying with unpretentious enthusiasm, and she banters with them easily. There doesn't seem to be a shade of reserve in her character.

When the labelling activity is over, the Indian speaker tells everyone to introduce each other by reading the descriptions of their partners. Brenda takes Wu Fang's description paper off his back and glances over it.

"Haha, my goodness," she says with a chuckle.

"What's so funny?" Wu Fang asks.

"My!" says Brenda as she smiles. "Your descriptions are *round, fat, corpulent* and *big-sized.* But one person describes you as *short.*"

"The first few descriptions are right," says Wu Fang with a frown. "But I am 180 centimetres tall, hardly short."

"I think it was written by Madam How," says Brenda, turning to the tall woman behind her. "Madam How, did you describe Mr Ting as short?"

"Yes," says Madam Ho, nodding. "I consider any man under 185 centimetres short."

"I get what you mean," says Brenda.

"Mr Ting," Madam How asks, "what's your weight?"

"It's 110 kilogrammes," says Wu Fang, blushing.

"Wow!" exclaims Madam How. "No wonder you look like a ball of flesh."

Wu Fang cringes. At school he is always being teased by his students for being fat, but he did not expect to become a subject of ridicule in today's workshop. When Brenda introduces Wu Fang over a microphone, many people roar with laughter. Although Wu Fang's face burns with humiliation, he manages to squeeze out a smile. He stutters when introducing Brenda, feeling stupid and useless.

In the next session, the Indian speaker asks everyone to rewrite William Butler Yeat's famous poem, "The Lake Isle of Innisfree."

"Look at the questions on the PowerPoint slide," explains the Indian speaker. "Answer the questions on where you would like to relax your mind, why you chose it, what you would like to plant there, what you can see there, as well as who you would pick as your companion in the place."

All the participants work on the questions immediately. It takes Brenda only a few minutes to answer the questions, and she goes to the privy with a few female teachers. Wu Fang peeps at her answers and is surprised to find that they are almost identical to his. He quickly crumples his paper into a ball and writes new answers on a new piece of paper.

When Brenda returns to the workshop room, the Indian speaker goes on with her instruction.

"First interview each other, and then write out a new version of 'The Lake Isle of Innisfree' based on the information obtained from your partner."

The room becomes a cacophony of voices at once.

"Mr Ting," asks Brenda, "where would you like to relax your mind?"

"The Mongolian Steppe," answers Wu Fang. "What about you?"

"My dream place is not far from here," says Brenda. "It's my mother's former workplace, Bario."

"Was your mum a teacher?" Wu Fang asks.

"Yes, she taught at SMK Bario in the first three years of her teaching."

Wu Fang's Iban mother actually taught in SMK Bario, too. He does not want the coincidence to be misinterpreted. So, he keeps it to himself for now.

"Why do you like Bario?"

"Well, it has temperate weather," Brenda says, "and lush greenery."

"It is indeed a beautiful place." Wu Fang smiles.

"Mr Ting, may I know why you prefer to relax in the Mongolian Steppe?"

A pang of guilt hits Wu Fang in his chest. His original answer was also Bario.

"It's . . . it's mysterious," Wu Fang stammers.

"You must have found the wide expanse of the steppe intriguing," opines Brenda.

"Yes, yes," Wu Fang replies and nods sheepishly.

"In Bario," enthuses Brenda, "I will plant all sorts of vegetables. The land is very fertile there."

"I know nothing of farming," says Wu Fang, avoiding the question of what he would like to plant in his dreamland. "The land of the Mongolian Steppe might not be arable."

"But it is full of grass," gasps Brenda in reply. "You seem to know very little about the Steppe. Why did you choose it then?"

"Er . . . er." Wu Fang, unable to answer her question, feels trapped in the entanglement of his ignorance. *Why didn't I stick with my original answer? It would show that we have something in common.*

"The Mongolian Steppe is teeming with cattle and sheep," says Brenda. "You can be a herder there."

"You are right." Wu Fang continues to curse himself for choosing the Mongolian Steppe blindly. Brenda must think he's a pea-brained idiot!

"Who would you pick as your companion in the Mongolian Steppe?" asks Brenda.

"I want to be alone there," Wu Fang replies.

"How pitiful," says Brenda. "I want to be in Bario with my parents."

"Why?" he asks, feeling foolish for saying that he wanted to be alone.

"It was not easy for my parents to bring me up," says Brenda. "I want to give them the best thing in the world."

During the next two days, Brenda continues to impress Wu Fang. In a forum that discusses the themes of Robert Louis Stevenson's *Dr Jekyll and Mr Hyde,* she presents her ideas lucidly and cogently.

"One of the themes of the novel is good versus devil," Wu Fang says in an attempt to impress her.

"No," corrects the Indian speaker, "it should be good versus *evil.*"

"Sorry," Wu Fang says, "it was a slip of my tongue."

"It's okay," says the Indian speaker. "Start your elaborations."

Wu Fang takes a deep breath and says, "Throughout the novel, Dr Jekyll is torn between good and evil. He is a well-respected philanthropist doctor in the mornings and a ma . . . mal . . ." The word is on the tip of his tongue, but it eludes him. Although Wu Fang is an English teacher, he seldom

speaks the language. He mostly speaks Malay, Iban, and Chinese with his colleagues and students.

"*Malevolent,*" Brenda whispers.

Wu Fang looks gratefully at Brenda and continues. "And a malevolent man who is bent on hurting others at night. He is overwhelmed with joy each time he commits a crime, but he regrets it when he transforms back to his evil self the next morning."

"It should be his normal self," says the Indian speaker.

"Sorry, my mind is a little confused today," says Wu Fang, struggling to restore his equanimity after making so many foolish mistakes.

"Make sure you are not like that in the real world of teaching," says the male assistant of the Indian speaker.

Everyone bursts out laughing. Wu Fang feels hurt when he sees Brenda joining in the mocking fun.

In the final session, which is a poster-designing activity, Brenda showcases her outstanding drawing ability. Many people sigh and squeal in admiration as she brings the characters in Guy de Maupassant's "The Necklace" to life with her nimble pencil. Wu Fang is good at art, too but being shy, he prefers to avoid letting Brenda and others know about it. Brenda looks radiantly beautiful in her eagerness to capture the mood of every character in her drawing.

When the workshop comes to an end at noon, many people shake hands with the speakers and swap phone numbers among themselves.

Wu Fang's eyes follow Brenda every where she goes in the room. Her smile, her voice, and her slender body captivate him. In his heart's core, love is unfolding itself in a perfection of puffs, folds, and eddying shapes. He wants to find out more about her.

Brenda, oh lovely Brenda. The woman of his dreams, the mirage that has turned into a reality. *You are my destiny.*

Wu Fang is walking in Brenda's direction, determined to get her telephone number. He is a few steps away from her when a tiny voice rings in his ear: *Wu Fang, are you sure you are worthy of her love? She is so good, and you are so lousy. She is a mentally healthy girl, and you are schizophrenic. The union of you two will only invite disaster. Haven't you made enough of a blunder of yourself before her these last three days? Surely she has a low opinion of you. You are not fit to love, not fit at all.*

Wu Fang stops in his tracks, unable to proceed. After saying goodbye to some teachers, Brenda leaves for the airport in a taxi. She never once looks in his direction.

Wu Fang doesn't know what to think. This dream—all these dreams and he lets her slip away. He decides that, the next time they meet at a workshop, he will make a better impression—he has to. This is the woman in his dreams. She is real.

But will she remember him? Or will she only remember that he made a fool of himself?

Reclaiming The Past

The sun peeks over the horizon. Hazy streams of light penetrate the windows along the cloistered corridor. Shadow tendrils stretch up the walls until they touch the curved ceiling and form an illusory archway that diminishes gradually towards a dark, hollow room at the farthest end of the worn walkway.

From the other end of the corridor, Tsin is inching in the direction of the room. The remnant cold from the previous night's heavy rain sends a shiver through her body. She instinctively pulls her collar tighter around her sagging neck. The streaming sunlight can hardly mitigate the chill. She sighs and draws a deep breath. The damp, fetid smell of the peeling walls invades her nostrils. *When was the building abandoned? In the mid-1940s or in the late 1950s?* She shakes her head with uncertainty. The corridor was once filled with the fresh, resinous scent of pine trees from the woods outside. The walls seemed to breathe in their lush blue paint, and the laughter of children vibrated through the air. It was a place where goodwill thrived, happiness was shared, and grief was forgotten. Though she

stayed in the Chinese orphanage for a mere two years, the fond memories remain etched in the depths of her heart forever.

The place is so desolate and devoid of life, a tiny, doubting voice speaks in her mind. *Why did you come here?*

"It is where I spent the early part of my life," Tsin answers.

It is so much different than before, grunts the doubting voice. *It symbolizes death and decay.*

"No," Tsin says, refuting the voice, "it is alive with good memories."

You are wrong, insists the voice. *Nobody cares for it any more. Stop dwelling on the past.*

"The past gives me the spirit to move on with life," replies Tsin. "I am always thankful to God for sending me to this orphanage."

Her parents died of tuberculosis, one after the other, when she was six. Orphaned at such a young age, she felt afraid, confused, and insecure. For two years, she had been handed from one relative to another like an unwanted doll before being sent to the orphanage at the age of eight. The moment she entered the building, her heart was full of misgiving towards the caretakers, Reverend Baker and his wife. They looked so much different from the locals with their tall stature, pale skin, strange-coloured eyes, and large noses. Would they treat her as badly as her relatives had done . . . or even worse?

Her fear was allayed when Mrs Baker gently clasped her hands and spoke to her in English-accented Chinese. "Don't worry, *Tsin*, you are at home now." The woman's voice was so calm and soothing. Her bluish eyes sparkled with motherly love and compassion. Reverend Baker was standing beside the gentle lady, exuding the same kindness with his smile. She had thought that she would never feel kindness again in her life. Overcome by

a sudden surge of grief for her parents, she threw herself into Mrs Baker's arms and cried. In her young mind, she knew she had found a safe sanctuary.

Indeed, the couple was kind to her. Whenever she woke up crying from a nightmare, they would be sitting by her bedside to comfort her. Though the orphanage was not a rich missionary organisation, there was always enough food and clothing for every child.

Tsin is now standing outside the dark room.

My goodness! exclaims the voice. *I hate the look of it.*

"But it is special to me," Tsin responds softly.

Why is it so special? the voice asks sarcastically.

"Reverend Baker and his wife taught us how to read, write, draw, sing, and play games in it," says Tsin, reminiscing with a smile. "They introduced us to Jesus Christ, the Son of God."

The reverend couple wanted to brainwash all of you with their religious teaching, says the voice.

"That is not true!" Tsin counters.

All foreigners come to China with an evil intent, says the voice. *They want the locals to lose their own identity.*

"Not all of them are like that," Tsin replies calmly. "Reverend Baker and his wife are compassionate towards the poor and the needy."

In what way?

"They gave us hope," Tsin explains. "In those days, orphans were treated as trash and sold to brothels. The reverend couple convinced us that, in God's eyes, we were the same as others."

Unfortunately, sneers the voice, *the glory of the room is over.*

"It remains the same in my mind," says Tsin.

That is not realistic, the voice mocks.

A smile crosses Tsin's lips as she recalls how the room looked in the past. If she remembers correctly, the windows were draped with white lace curtains. Children's drawings and strips of gospel quotations were pasted on the walls, giving the room a warm, colourful look. There was a bookshelf against the back wall. It was a treasure trove of knowledge that contained many storybooks, copies of the Bible, and encyclopedias. A bronze cross was placed high above the blackboard, which spanned across the front wall. It seemed to bless every person and item in the room with its lustrous metallic glow. Facing the blackboard were three rows of neatly arranged wooden desks and chairs.

"Tsin," Mei Fung, a ten-year-old girl who was Tsin's best friend, liked to complain, "why do you always sit in the front middle desk?"

"I am able to hear the stories told by the Bakers more clearly," replied Tsin, a year younger than Mei Fung.

"Me too. I love listening to their stories," said Mei Fung.

"They are fun," said Tsin, "and full of God's love."

"What do you think of their Chinese?" asked Mei Fung, giggling. "Their English-accented Chinese is quite amusing."

"I do find it funny," agreed Tsin, "but the way they tell stories is captivating. They use a lot of pictures and gestures."

"I love the Bakers," said Mei Fung. "They are like friends."

"No," corrected Tsin, "they are our parents."

Tsin gazes into the room. She can see a film of tangled cobwebs hanging in thick strands from the ceiling. They glint off the low light that steals in through the doorless entrance. In the pale dimness, she can make out the outlines of scattered, overturned desks and chairs on the floor. She sighs and walks into the room. The strong smell of dust almost chokes her. While moving inside, she keeps brushing the cobwebs off her body.

The room, darkened by the closed wooden shutters, makes her breathing quicken, and the hairs at the back of her neck rise. She decides to open the shutters to let some light in.

Sadness overcomes her as she recalls the day she left the orphanage at the age of ten. Her youngest uncle from Kuching found out that she was in the orphanage and decided to adopt her. He had been close to her family before moving to Sarawak. Tsin was touched by her uncle's sincerity and agreed to go to Kuching with him. Her tears fell like rain on the day she bade farewell to everyone in the orphanage.

"Reverend Baker," Tsin sobbed, "I am reluctant to leave you and Auntie."

"Don't cry," said Mrs Baker, "you're finally reunited with your uncle."

"Reverend Baker," said Tsin's uncle, extending his hand, "thank you for taking care of Tsin so well."

"It's our responsibility," said Reverend Baker, shaking the hand of Tsin's uncle. "We have treated her like our own child."

"I will treat her like mine, too," said Tsin's uncle.

"Mei Fung," Reverend Baker called out, "Give Tsin the new Bible."

"Yes, Reverend Baker." Mei Fung put a glossy Bible into Tsin's hands.

"It's a parting gift," said Reverend Baker.

"Thanks, Reverend and Mrs Baker." Tsin put the Bible close to her heart.

"Read the word of God every day," said Reverend Baker. "It will give you peace of mind."

"I will," Tsin promised.

"Pray wherever you are," said Mrs Baker. "God will be with you."

"I will do what you say. I love all of you."

Tsin hugged Reverend Baker, Mrs Baker, and Mei Fung. Many children in the orphanage shed tears. Before Tsin left with her uncle for the harbour, Reverend Baker conducted a service to bless her. From the horse-drawn cart as she left the orphanage, she cast a final glance at the building and said, "I will come back here when I grow up. I will."

After several weeks of sailing, they reached Kuching and began a new life. Her uncle owned a small vegetable farm in the British colony. His wife was a small, soft-spoken lady who could not conceive. Tsin's presence filled the childless void in their life. For a short while, they were all happy. But when she turned twelve, Japan invaded Sarawak. Life was hard under their occupation. Her family suffered, yet they were able to pull through the difficult period.

Five years after the Japanese surrendered, Tsin met Nam, a humble teacher who taught in a Chinese primary school. They married and were blessed with three boys and one daughter. Though content with life, she always recalled her time in the orphanage with fondness. She missed the Bakers and always told her children how good the couple had been to her.

Upon reaching one of the windows, Tsin turns the lever handles with both hands and opens the wooden shutters. Dust flies everywhere, and a shaft of light floods in. She squints against the morning brilliance and lets the incoming, swishing wind brush against her cheeks. The air reeks of noxious chemical fumes. Sadly, the stretch of woods beside the orphanage was levelled for the construction of roads and factories many years ago.

The shady woods meant a lot to Tsin and Mei Fung. They enjoyed ambling through the tapestry of trees and the tangle of ferns and grass on hot afternoons. They admired the scenery and

picked flowers. It never occurred to them that the woods would suffer such a fate. The thought brings tears to her eyes. She feels like she has lost a dear friend. Tsin proceeds to open the other windows. Instantly, the room becomes alive with light. Her eyes glide across the room, absorbing the sight that unfolds before her. The walls, once laden with children's drawings and Bible quotations, are totally bare. The bookshelf against the back wall is also gone. Only a few chairs are left on the floor, and they are either upended, tipped on their sides, or reduced to fragments. Her eyes settle on the front wall, quite surprised to see that the blackboard remains intact in its place. The bronze cross still hangs above the blackboard, but it has turned black with age—only a faint patina is visible.

Tsin makes her way to the centre of the room with slow, measured steps. When she finds the spot where her seat was once situated, she kneels down on the dust-layered floor. A sharp pain comes to her rheumatic knees, but she does not care. She gazes up at the cross, eyes turning misty again.

The Reverend couple was chased out of China during the Second World War, says the voice. *Never to return.*

"My heart tells me that they remained in China," replies Tsin.

That is only a wishful thinking, retorts the voice.

"They were good servants of God," Tsin says. "They wouldn't leave their flock behind. They would come back."

If they did, sneers the voice, *they would have been chased out again when China was declared a republic in 1949.*

Tsin does not know how to answer.

If they didn't leave like the others, adds the voice triumphantly, *they would have been persecuted.*

Tsin sighs and shakes her head.

Your God could not save them. The voice roars with laughter. *Long live the republic!*

"No matter what happened," says Tsin firmly, "they were victors of life. The seeds they planted in us are growing robustly."

But . . . replies the voice, falling short of words.

"They gave me the dignity to live," Tsin goes on, "and they prepared me for a better life."

You are hopelessly positive.

"That is what I am made of," says Tsin proudly. "No force can crush God's love. It spreads among us like ripples. The legacy of love lives on forever."

Unbelievable, the voice declares before tapering off into silence.

Tsin's uncle died in his sleep when she was thirty-four. After four years, his wife joined him. Tsin took their death very hard, but she was able to get over her grief through prayers. Time lapsed and receded; all her children grew up and finished their university education. They became successful professionals and got married one after another, having children of their own. Tsin and her retired husband now enjoy their status as grandparents.

Tsin is now seventy-six. She considers herself very lucky to be able to set foot on the soil of Chung-San, her hometown, after sixty-six years. Two days ago, she reached the town with her husband and two of her children. She was filled with relief when her children found out from the locals that the orphanage was still standing. When they came to the derelict building, she felt overwhelmed by strong emotions. The moment they came to the cloistered corridor, Tsin insisted on going into the classroom on her own.

"Mama, are you okay?"

A soft female voice cuts through the stillness of the air, interrupting her flashback. She looks over her shoulder and sees Yong Shi, her daughter, standing behind her. Her husband, Nam, and her eldest son, Yong Chin, are smiling at her from the doorway. Her other children could not come to Chung-San because they were busy with their work in Sarawak. The sight of her family makes her face relax and her eyes twinkle.

When she first came here, she had no family.

"I'm all right," replies Tsin.

"Don't worry, we will ask more locals about the whereabouts of the Bakers," says Nam as he looks lovingly at his wife.

"Mama, always have hope," reassures Yong Chin. "That is what you taught us."

"It's okay," says Tsin as she smiles. "The past is too blurred and distant for us to grasp. I am happy to have finally come back here. It is where my new life began, when I was given hope for a better future by the Bakers. They will always hold a special place in my heart."

Tsin asks her husband and children to kneel down beside her. She leads them in saying a prayer of thanksgiving to God for showing her the way home.

Suicide

"I am going to end my life tomorrow," Ah Lien said to herself, as she gazed at her sleeping husband. It was something she had been thinking about for weeks. "I have had enough."

The thirty-five-year-old woman woke up early as usual, making her children's favourite pancakes. The delicious aroma of the sizzling pancakes took the edge off the three kids' sleepiness. Making pancakes was Ah Lien's speciality. She could achieve a perfect ratio of milk to flour without measuring the ingredients.

When the last pancake was crispy and brown on both sides, Ah Lien placed it at the top of the other cooked pancakes on a platter. She told her eldest daughter, Ah Ping, to carry the piping-hot breakfast to the table, "Ping, be careful and walk slowly."

"Yes, Mama."

"Put six pancakes on Papa's plate," instructed Ah Lien while handing a pair of tongs to Ah Ping. "Four on each of your plates and two on mine."

Ten-year-old Ah Ping obediently did as she was told. Kai Tak, Ah Lien's husband, took two in his large hand and slathered thick butter on top of them. He chomped down on the pancakes

with wolfish voraciousness. The butter melted and trickled from the corner of his mouth. Ah Lien heaved an inward sigh. Kai Tak's table manners were still appalling—one of the grudges she held against him. Firm in her decision to commit suicide, she found chiding him pointless. Over the years, she had reminded him far too many times of the importance of eating politely in front of their children. If she had not married him, she would have fared much better in life in Kuching, earning stable pay as a supervisor at Ngiukee Supermarket or working as a respected dental nurse in the government hospital.

"Mama, may I have jam for my pancakes?" asked Ah Fei, the second son, a plump boy who took after his father in terms of physique.

"Mama, I want jam, too," said Ah Ming, the youngest son.

"We've run out of jam," said Ah Lien in a flat voice. "Use condensed milk."

"Condensed milk is more suitable for tea," said Ah Ping. "I'll settle for butter."

Ah Lien looked at them with a blank mind. She could not bring herself to eat the two pancakes on her plate. Ah Ping, Ah Fei, and Ah Ming relished their meal like their father.

"Lien," Kai Tak said, "guess what I dreamt last night?"

Ah Lien looked at him with no interest.

"I dreamt that a woman was crying sadly by the sea, trying to commit suicide."

The fork in Ah Lien's hand almost dropped. Taking a deep breath, she hesitantly asked, "What do you think it means?"

"It could be a good omen. Who knows?" said Kai Tak, wiping the grease off his lips with a piece of tissue paper as he contrived to gaze at her.

Ah Lien forced out a faint chuckle, in her attempt to look amused.

"Can you interpret the dream into a four-digit number for me?" asked Kai Tak. "Maybe our luck will finally change."

Ah Lien looked at him with disbelief. In her mind, she sneered at the suggestion, but she tried to conceal her reaction from Kai Tak. How crazy it was to ask a person who was going to commit suicide to do a favour like that for him. Nevertheless, out of habit, she nodded to signal her consent.

After he had finished eating, Kai Tak looked around and noticed that Ah Fei was still munching on a pancake. There were still two pancakes on his plate. Ah Ping and Ah Ming had just finished theirs.

Kai Tak quickly grabbed Ah Fei's plate and transferred the remaining pancakes on Ah Ming's plate.

"Why, Papa?" Ah Fei protested. "I haven't finished eating!"

"You are so much bigger than Ah Ming," said Kai Tak. "Let your brother have more."

Ah Ming's face beamed at the sight of the two pancakes on his plate, while Ah Fei looked with anger at him.

"Papa," hissed Ah Fei, "you are being unfair."

"You can have mine, Ah Fei," said Ah Lien.

"No, I want mine back!" insisted Ah Fei.

Kai Tak's face darkened and he told Ah Fei to shut up. Ah Ming cocked a snook at his fuming brother.

Ah Fei stood up and threw his empty plate at Ah Ming. The little boy ducked, and the plate shattered on the floor.

"My goodness!" gasped Ah Lien. Ah Ping gasped, too.

"Delinquent son!" Kai Tak said as he banged the table with his hand. He went round the table to where Ah Fei was sitting.

"Don't, Kai Tak!"

Slap!

Ah Lien was too late to stop him from inflicting the punishment on Ah Fei. She shook her head. *Why did Kai Tak overreact like that? He had started the conflict by taking Ah Fei's pancakes.*

Covering his throbbing cheek with one hand, Ah Fei stormed into the family's bedroom and slammed the door closed behind him.

"A good-for-nothing boy," shouted Kai Tak, his face flushed with anger. "How come I have a son like him?"

Ah Lien's face turned pale. *Is he blaming me?* He never seemed to like the middle child. She knew why, too. She had given birth to Ah Fei several weeks after their bankruptcy. To settle their debts, they had sold off their shop and house. The house that they currently inhabited was a rented one. Kai Tak had spent so much time wallowing in self-pity that he had neglected to pay attention to Ah Fei. To rebuild their life, they had decided to sell *Kolo Mee*[3]. They were not making much of a profit from the business, so life had always been a struggle for them. Ah Ming was born at a time when Kai Tak became less moody. Hence, he tended to dote on the youngest child. As for the precocious Ah Ping, she was also the apple of his eye because she was obedient. Poor Ah Fei—he always found himself unloved by his father. With a temper as bad as Kai Tak's, the two were constantly at odds with each other.

Ah Lien snapped out of her reverie when Kai Tak asked Ah Ping and Ah Ming to get into his rickety car.

"Hurry!" barked Kai Tak. "Or else you will be late for school."

[3] A popular noodle dish in Sarawak, Malaysia

"What about Ah Fei?" asked Ah Lien.

"No," Kai Tak said, shaking his head, "I don't want to take him. The sight of him makes me unable to drive well."

Ah Lien did not know what to say. This turn of events disrupted her plan.

"I will only be back this evening," added Kai Tak. "After I take the kids to school, I am going to send our car for repairs."

With that, Kai Tak left with the two kids. The bedroom door flung open at the sound of the roaring engine. Ah Fei dashed out of the room, shouting through sobs, "I want to go to school! Don't leave me behind!"

Ah Lien hugged the crying boy and calmed him down with soothing words. Dramas like this were becoming routine, and Ah Lien was fed up—one of her reasons for ending her life. Enough was enough. When Ah Fei was done crying, Ah Lien, in a gentle voice, told him to sleep. The moment she could hear the child snoring in his bed, Ah Lien sighed with relief and swept the broken plate into a dust pan. She gave her uneaten pancakes to O Bu Kau, a black dog that she had reared for six years.

After washing the dishes, she sat on the only settee in the house and read the latest issue of the *Australian Women's Weekly*. It had been her favourite magazine since her days as a student at St Mary's. She was one of the few wives in the neighbourhood who could speak, read, and write in English. Kai Tak, in contrast, spoke no English, and was always the subject of contempt among her father and siblings. They had strongly opposed Ah Lien's marriage to him and had been spitefully sarcastic towards her since their wedding. Due to the unstable income from the sale of noodles, Ah Lien had consistently gone back to Kuching to borrow money from them. Each time they passed her the requested sum of money, Ah Lien would try her

best to ignore their cold, mocking looks. She had no dignity in front of them. In their eyes, she was as lowly as her Mirian husband.

Streaming sunlight dappled Ah Lien's body through the jalousie window. Ah Lien was inadvertently lulled to sleep by the quietness around her.

"Ah Lien, think carefully before you kill yourself," a familiar voice spoke to her.

She opened her eyes and saw her Bidayuh mother. She was dressed in a white kebaya.

"Mak!" Ah Lien exclaimed in English. "I've been longing to see you."

Ah Lien's mother had passed away nine years ago, two hours after Ah Lien had given birth to Ah Fei.

"Be brave," Ah Lien's mother said in a sombre voice. "Your family still needs you."

"I am tired of everything, Mak," lamented Ah Lien. "There are always quarrels in my house. Kai Tak's business is shaky. I have pawned almost all the jewellery that you gave me. Papa and Adik look down on me."

Ah Lien's mother smiled and said, "Be patient; God will reward you someday."

Ah Lien burst into tears and declared, "No, I can't. I want to be with you."

She wanted to clutch at her mother's sleeve, but a heavy languidness spread through her body. Her hand dropped to the arm of the settee and her mother's image began to fade.

"Don't go, Mak," pleaded Ah Lien. "Take me with you."

"Be strong, Ah Lien," said her mother. "Your children are your life. If you kill yourself, you kill them, too."

Ah Lien heard a roll of thunder, and her mother disappeared.

"Mak, Mak!" Ah Lien woke up with a start. She had been dreaming.

Ah Lien wiped tears off her face. Her mother's words were still fresh in her ears. *Yes, my children are my life, she thought. But I have had enough. They will be all right without me, Kai Tak will take care of them.* All she wanted to do was to die and join her mother; she did not want to live in stress any more.

Ah Lien got off the settee and took some one-ringgit coins from her handbag. She wanted to walk to the beach, which was not far from her neighbourhood. She would walk deeper and deeper into the sea and let the water take her life. Her pain would be gone forever. Kai Tak and her children would be sad for a while, but they would forget her as the years went by.

As Ah Lien made her way to the door, she found Ah Fei sitting on the door sill. *When did he wake up and creep to the door?* The sight of him made her reconsider what she was about to do. She paced back and forth, hemming and hawing. *Should I go to the beach or not?*

As she grappled with her decision, Ah Fei opened his mouth and sang a Chinese song:

> "Let us join our hands and form a circle,
> Make it as round and wide as can be.
> With our love and trust for one another—
> No matter what happens—
> We are a family.
> As long as we keep the circle round,
> Nothing can separate us."

Like a knife, the words pierced through Ah Lien's heart. She shook her head and tried to ignore her gnawing conscience.

Stooping down, she tapped Ah Fei on the shoulder and said, "Fei, let Mama pass. Mama wants to go out."

Ah Fei rose and stepped aside, letting Ah Lien pass. "Where are you going, Mama?"

"I'm going to town. You sit quietly at home," said Ah Lien.

"I want to go with you."

"No, Fei, Mama has something important to do."

"Ma . . ." Ah Fei begged.

"Be a good boy," Ah Lien said. "I won't be long."

Ah Fei nodded and stopped pestering his mother. But then he asked, "Where is your purse?"

"I won't be needing it," she replied absently.

Ah Lien stepped into the glare of the ten o'clock sun and walked towards the gate.

Ah Fei sang the same song again. Ah Lien quickened her pace, but his childish voice continued to follow her.

Tears blurred Ah Lien's vision. Strong mixed emotions raked her slender body.

> "We are a family.
> As long as we keep the circle round,
> Nothing can separate us."

Ah Lien covered her ears with both hands and hurried through the open gate. Her mind reeling in confusion, she did not know how long it took before she reached the beach. She sat on a log and broke down in tears. She remembered Kai Tak's dream and pondered its meaning. Again, she thought of her mother's advice and Ah Fei's song.

"God, what should I do?" Ah Lien groaned, looking up at the sky.

Many questions flitted through her mind. *What would happen to Kai Tak if I killed myself? Would he lose the will to live? Could he manage the noodle-selling business without my assistance? What would become of my children? Would they be mocked for not having a mother? Would they hate me for leaving them? Would they have enough food to eat? Could they grow up into mentally and physically sound adults? Would Kai Tak beat Ah Fei more often?*

Her resolve to commit suicide began to crumble.

As she turned around to leave the beach, she noticed a broken licence plate wedged into the sand. The four numbers, *1992,* were the year of her mother's death and the year of Ah Fei's birth. Again, she thought about Kai Tak's dream and his request to interpret it for him. She had always hated his gambling, and wasting money on four-digit lotteries.

On her long way back home, she passed the four-digit shop that was always crowded. She paused before going inside. Without understanding why, she wrote *1992* down twice on a piece of paper, once in the same order and once in reverse order, just in case. If she won, she would not tell Kai Tak. The money would be for her, her children, and, perhaps, to buy back some of the jewellery she had pawned.

When Ah Lien returned home, weary and in tears, Ah Fei called out to her happily at the door. O Bu Kau welcomed her with a frenzy of ecstatic yelps and jumps and tail-wagging. Overwhelmed with joy, she pulled Ah Fei into her arms and gave him a hug. "Yes, Ah Fei," she said. "No matter what happens tomorrow, we are a family."

We Are All the Same

The bus comes to a groaning halt at the bus stop next to the Parkson Mall. Its electric-powered door swings open and I board it. After dropping some cash into the fare box beside the driver, I edge my way through a line of standing passengers towards the rear of the bus. When I spot an unoccupied seat beside a red-shirted Iban man, I grin to myself in relief.

Having made myself comfortable in the seat, I decide to close my eyes for a short rest. Something smelly attacks my nostrils. Crinkling my nose in disgust, I look sideways at my neighbour, who seems captivated by the view of buildings whirring past the window. *Yes, the odour is coming directly from him. How many days has it been since he took his last shower? No wonder the seat was left vacant!*

I suddenly find myself staring at the man eye to eye. My surprise turns to shock when I realise that his face is mottled with bruises, scabs and open wounds. Before I can tear my eyes away from the repulsive sight, he cracks a smile and says in Malay to me, "Hi, going home?"

I am stunned for a moment, not knowing how to answer. Nevertheless, I nod.

"Does my face frighten you?" asks the man, as he looks at me with a penetrating gaze.

The question throws me off guard. I shake my head and stammer, "N-no."

"It's okay, don't feel bad about it," the man says, waving his forefinger from side to side.

There is something cheerful in his demeanor.

"May I know what happened to you?" I venture, my embarrassment easing a little.

"Oh, *my face?*" he asks in a calm voice, pointing to his wounded face. "I fell off my motorcycle four days ago. A car knocked me from behind."

"Good grief!" I exclaim.

"The motorcycle overturned and slid across the road before being run over by a truck," he continues, his face impassive. "It was reduced to a total wreck."

"I am sorry to hear that," I say.

"It's okay. I'm glad that I am alive," replies the man.

"Ya, you were fortunate to have escaped death," I say.

The bus is now rounding a sharp bend. We both lurch forward in our seats. The standing passengers beside us tighten their grips on the overhead railing to steady themselves.

"Who took you to hospital?" I ask.

"The driver who knocked me down," the man answers.

"Did he compensate you?"

"Ya . . . not much though."

I decide not to ask the amount lest it sound intrusive. Instead I ask, "When were you discharged from the hospital?"

"Yesterday."

I am baffled by the man's reply. He should have stayed home to rest today!

He seems to be able to read my thought and says, "I visited my workplace just now."

Amazed, I ask him what made him go back to work.

"I pleaded with my boss not to give me the boot. I had been fired on the day of the accident."

"How inconsiderate of him!" I burst out incredulously.

"He insisted on firing me, saying that I had neglected my work."

"But you had no choice."

"He's a typical boss—cold and insensitive. There was nothing I could do," says the man. A pall of gloom descends upon his face. In a few weeks' time, it will be a patchwork of new skin.

The bus pulls over beside a school and picks up more passengers. The bus driver keeps hollering at the standing passengers in the front to move to the back. His voice is hoarse from the strain of anger. When he sees that his order has been obeyed, he turns the ignition on and drives the bus away from the stop. The presence of school pupils fills the bus with a sweaty odour. For some reason, their innocent-looking faces make me uncomfortable.

The Iban man interrupts my diverted attention by saying, "Things keep getting from bad to worse if you are doomed with bad luck."

"Oh," is all I can say. My heart is full of compassion towards the man. Yet I know that many bosses prioritise productivity over their employees' welfare.

"After leaving that dratted workshop, I went back to hospital to ask for some antidepressants. But the doctor did not want to give me any." The man curls his calloused fingers into a fist.

"Did you go to the psychiatric clinic?" I ask.

"Yes, my mood has been unstable since the accident!" the man says with a perceptible spasm of indignation.

"Do you go there regularly?"

"Yes, I have been a regular outpatient since I came out of jail two years ago."

I cover my mouth to stifle a gasp.

"You're shocked, aren't you?"

I do not deny it.

"You look down on me?" the man's voice wavers as he speaks.

"No. Everyone has their ups and downs." I give him a reassuring tap on the shoulder.

The man runs his fingers through his mop of greasy, shoulder-length hair. He then clears his throat and says, "That doctor, Ida Mustafa, insisted that I was all right and that I needed no antidepressants. Stubborn woman." He sighs.

Dr. Ida Mustafa? What a familiar name! The man couldn't have been lying!

"What colour is your psychiatric outpatient card?" I ask, testing him.

"It's out of the ordinary—pink," he replies without hesitation.

I open my knapsack and withdraw a card of similar colour. The Iban man looks at it with dilated eyes.

"You have the same card!"

I nod.

"I never thought that we were the same kind of people!" the man says.

"What do you mean?" I ask, frowning.

"*Orang Tak Siuman!*"

Orang Tak Siuman?! My goodness! Mentally imbalanced people!

"I am not mentally imbalanced!" I remonstrate, "And neither are you!"

"Normal people always perceive all psychiatric patients that way," the man says.

"That's prejudice!"

"When did you start going to the psychiatrist?" asks the man.

"Last year," I answer.

"For what problem?"

"Depression. What about you?"

"I have a tendency for violence. My doctor told me that it was bi-bi . . ." The word is on the tip of the man's tongue but he can't remember it.

"Bipolar disorder," I suggest.

"Ya, that's it! How do you know?"

"My doctor diagnosed me as suffering from the same disorder," I reply, inadvertently divulging more information than I would have preferred.

"Ha ha! We are the same after all!" laughs the man, his eyes narrowing into slits.

I shoot the man a reproachful glance, but he is not aware of it.

"When my mind goes reeling, I am violent and unable to work. Does that sound familiar to you?"

I shake my head impatiently, though I remember how bad my temper was years ago. At one point, I was unable to teach at school for weeks because of my violent mood swings. My emotions are much stabler now. However, I still need to go back to hospital for a fortnightly injection. To calm my mind, I like to read or wander around in shopping complexes.

The bus goes over a bridge and is now rolling smoothly along the road to Permyjaya, the largest housing area in Miri, which is where my house is situated.

"I don't think your bipolar disorder is as serious as mine," says the man.

"No, not at all," I say, rolling my eyes.

"*Celaka*!" curses the man out of the blue. "Without antidepressants, it's difficult for me to sleep at night. The wounds on my body cause me so much misery."

"How do you make yourself sleep?" I inquire.

"I booze till I am drunk," is the man's reply.

"That is not good for your health."

"Do you think I have a choice?"

I fall quiet. I cannot imagine what I would do if I were in the man's situation.

"Do you want to see the wounds on my body?" the man asks. Before I can say no, he rolls up his shirt and shows me the ghastly wounds on his chest and stomach.

"There are some more on my back and legs," he adds.

Now I understand why he smells so bad. It is impossible to take a shower with such a wound-laden body.

Suddenly, the man says, "How I wish I could return to my *Kampung*. But I don't have enough money."

"Don't think of going back to your village now. Rest as much as you can," I advise.

"The hell with my Chinese boss. How I wish I could punch him in the nose!" the man says through clenched teeth, cracking his knuckles.

"Be patient," I say, giving the man another bit of useless advice. I am feeling increasingly uncomfortable in his presence.

"He will never understand my plight. I am almost penniless," the man says in despair, his eyes glazing over with sadness.

I draw a deep breath. What is he trying to say? Is he hinting that I should give him some money?

Fretfully, I look around and find the bus approaching a church. In ten minutes, it will be within the vicinity of my house.

"Oh, the bus will be reaching my house in a minute. I have to go now." I rise and press the bell above me.

The man does not look at me. In brooding silence, he holds his head with both hands. His face is contorted with emotion. Little does he know that I am lying.

The bus lurches to a stop and I get off it as soon as I can, as if escaping a plague.

It has taken me almost twenty minutes to walk all the way home. "Silly me!" I scold myself. But I could not bear talking to the man any longer. The more the Iban man talked about himself, the more I became aware of my own unpleasant past. Several years ago, I was warned by the Education Department for being too violent with some students. I am still smarting from the outcome.

When I am at my house gate, the piercing light of the lowly hung sun shines directly into my face through the filigree tree branches. It seems to admonish me for my action. I feel ashamed of myself for not helping the Iban man. "What if it had been me?" I murmur to myself. "Are we not the same?"

Two Hundred and Fifty Buns

It was late in the afternoon. Ah Hui, Weng Weng, and I were sprawled on the floor of our living room playing Billionaire when a white Mazda pulled up in front of our gate. The driver, a fashionable young man, came into the house looking for Papa. His dark purple sunglasses captured our interest. Papa's face brightened when the visitor said *two hundred and fifty* in his thick Fuzhou accent.

He shook the young man's hand and thanked him profusely. And then he saw him off at the front gate.

In a flurry of excitement, Ah Hui—my older sister—ran to Mama's side with my brother and me in tow. Tugging at Mother's sleeve, she asked, "Mama, is it true? That sunglasses-wearing man has ordered two hundred and fifty steamed buns from us?"

"Yes, he will come and collect them tomorrow evening," Mama said, smiling.

"Will Papa be selling buns in the market tomorrow evening?" I asked.

"No, Papa will be taking all of us to a movie."

"Yippee!" exclaimed Weng Weng, my younger brother.

"How much will we get from the sale, Mama?" asked Ah Hui, curious and concerned at the same time.

"Three hundred ringgit," said Mama, her eyes sparkling.

"That's a lot of money!" piped Weng Weng, capering in delight.

"Yes, indeed," said Mama. "That money will recoup the amount your father spent on the repairs of our car."

"Hey, you three," hollered Papa, coming into the house from outside." It's time for you to do your homework."

"Okay, Papa," my siblings and I chorused happily as we thought about the next day's movie.

That night, we all fell into a blissful sleep. It had not been easy for Papa to earn such a huge sum of money. In my heart, I thanked the Mazda-driving man for doing us a good turn.

At ten o'clock the next morning, my parents began making steamed buns. They went through the process of weighing flour, mixing overnight-fermented yeast with the flour, and kneading dough. While waiting for the dough to proof, Mama wasted no time preparing the filling. She put pre-marinated pork into our old oven and baked the meat until a spicy, mouth-watering aroma drifted out and filled the entire kitchen. And then, while waiting for the meat to cool, she made gravy for the buns. First, she sauteed shallots until they were fragrant. Next, pre-toasted flour was added. She diluted the flour with water and seasoned it with barbecue sauce, sugar, and salt. She kept stirring the gravy to prevent it from curdling. After straining it, she left it aside and cut the slightly charred meat into cubes. She poured the gravy over the meat and mixed it well.

When the dough had doubled in bulk, Papa mixed it with a fresh amount of flour. He kneaded it gently until it was smooth.

He left it to proof again. After thirty minutes, he portioned out the dough and rolled each chunk into a circle with a roller. With Mama's help, Papa spooned the filling onto the centre of each rolled-out piece of dough and sealed it by pleating the edges. Ah Hui, Weng Weng, and I watched on with keen interest. Occasionally, Papa and Mama would let us try sealing a few buns, but our efforts produced miserable-looking rows of pleats on the buns.

By the time my parents had finished sealing the buns, it was already three in the afternoon. They arranged them neatly in bamboo steamer trays and stacked them up on the stove. All the buns were steamed on high heat. While the buns were steaming, my siblings and I were told to play in the shady backyard. The air in that rented house of ours was as hot as a kiln. Our parents' faces were slicked with sweat, and their clothes stuck to their skin. The sole fan in our house whirred ineffectually in the kitchen.

Every fifteen minutes, the buns were checked to see whether they had been sufficiently cooked. And each time the lid was lifted up, hot steam burst out in clouds from the steamer. My parents would keep a good distance from the released vapour to avoid being scalded. With gloved hands, they transferred the cooked buns onto platters and heaped yet more uncooked buns onto the steamer trays. Sweat trickled down their faces in tiny rivulets.

By four in the afternoon, all the buns were cooked. Puffed up and fluffy in sheer whiteness, they cracked beautifully across the centre to reveal the reddish, savoury filling inside. Our buns were Hong Kong—style pork buns, and not many people could make that kind with success. It is not easy to make the skin because the yeast fermentation itself takes many hours.

I looked at the fruit of my parents' labours with pride. In two hours' time, the sunglasses-wearing man would come and collect them. Papa would then earn three hundred ringgit and take us to a movie.

At six o'clock in the evening, all of us waited outside the house in eager anticipation for the man who would change our fortunes. We chatted excitedly with Papa.

"Papa, what movie will we watch?" I asked.

"A kung fu movie with Jackie Chan in it," said Papa.

"Yay, I love Jackie Chan!" shouted Weng Weng.

"Papa, when you've received the money, will you grant my wish?" asked Ah Hui.

"Yes. What is it?"

"Can you buy us 'Candy-Candy', the famous Japanese comic series?"

"Sure, no problem," replied Papa, grinning.

"Thank you, Papa!" chirped Ah Hui.

The man did not show up at the promised time. Our wait turned out to be an interminable one. Evening segued into night, leaving behind some remnants of red, purple, and gold in the sky.

"Mama, it's almost seven! Where is that man?" groaned Ah Hui.

"Robert, can you phone that man?" said Mama in a voice filled with worry.

"Okay, I will go next door and telephone Mr Tang," said Papa.

While waiting for Papa to come back, I was on the constant lookout for any car that resembled the man's white Mazda on the road. Every time I saw a white car approaching our house from afar, I would yell, "The sunglasses man is coming, the sunglasses

man is coming!" My excitement would quickly dissipate when each of them whizzed past our house.

Fifteen minutes passed. Papa returned home with bad news. The Mazda-driving man had changed his mind and he would not be collecting the steamed buns from us. Our hopes of earning three hundred ringgit and watching a movie were dashed. Never in my life had I seen my parents that hurt, angry, and disappointed. Ah Hui, Weng Weng, and I cried, our hopes of Jackie Chan and "Candy-Candy" comics fading like steam in the night air.

"Robert, can you phone Mr Tang again? If he had a modicum of conscience, he would pity us and collect the buns," pleaded Mama, her voice choked in the tears she was trying to hold back.

"I have tried my best, Ah Lan. But he was adamant!" bellowed Papa, his face flushing with fury.

My parents could not for the life of them figure out why that man went back on his word.

On my way to the bedroom, which I shared with my siblings, I saw Papa looking morosely at all the uncollected packets of buns on the table. His brows were tightly knitted, and his shoulders heaved with the force of the emotion within him. The sight brought a lump to my throat.

At bedtime, I told Mama how I felt.

"Mama, it's not fair. That man should not have lied to us."

"Tai-Tai, we can't do anything. That's life," said Mama.

"Does it mean that bad people can get away with breaking promises?"

"I am not sure. But we should avoid doing that all the time," advised Mama.

"Curse that man. I hate him. The world is hopeless with liars like him!"

"Don't be like that, Tai. The world is hopeful as long as we practise good values."

"How should we practise good values, Mama?"

"Be honest, be truthful, be hardworking, and be persevering. Nobody can harm us if we uphold all these values."

"But will you and Papa be in the mood to sell buns again tomorrow?" I asked.

"We have to," said Mama, her voice full of benign love. "We love all three of you. Selling steamed buns is the only way we earn a living. However sad we are, we should move on with our lives. Be not afraid of failures."

After Mama had switched off the light and left, I made myself a silent promise: *I will study hard to give my parents a better life when I grow up. And I will see to it that they get more than three hundred ringgit every month.*

No Escape from Fire-Sterilized Injection

One morning, after recess, a team of health personnel came to my school to give all pupils free dengue vaccinations. The sight of them toting medical tools and equipment into the school's resource room gave almost everyone in my primary-four class the heebie-jeebies. Despite our teacher's repeated reassurance that the injection pain would be as slight as an ant bite, many so-called tough boys and girls in my class grimaced and squealed in apprehension. Having a low pain threshold, I could not help shaking from head to toes. An overpowering sense of dread and foreboding washed over me. I had once been bitten by fire ants, and the pain was vicious. While waiting for our turn to receive the vaccinations, I kept riffling through my Chinese textbook in a futile effort to calm myself down.

After forty minutes, a school prefect walked into our classroom and told us to get ready for the vaccinations. All of us erupted in groans. Madam Chai hushed us and made us stand in a single file according to the alphabetical order of our names. And then she ushered us out of the classroom. We stopped at the

front door of the resource room, the makeshift injection room. Our long queue of fifty-five pupils spanned three classrooms. I stood in the middle of the line, like a criminal going to the gallows. A short, heavyset nurse was standing at the door with a list of our names in her hand. Her job was to call us one by one into the room. Every time she barked out a pupil's name in her executioner's voice, there would be gasps of panic rising from the front of the line. Each injection session was brief, and every pupil who came out of the room would snivel all the way back to the classroom.

I was busy counting the gradually shrinking number of pupils before me when a chirpy voice rang out behind me. I looked over my shoulder and saw Miss Chiew talking to Man Zhou, the boy who stood behind me.

"Are you afraid, Man Zhou?" asked Miss Chiew, a young and bubbly temporary teacher who taught us civic education. She liked telling us jokes, but I was always slow to perceive her humour.

"A little, Miss," answered Man Zhou while wiping beaded sweat off his forehead with the back of his arm. It was quite hot that day—not even a breath of wind. The air reeked of body odour.

"What makes you afraid, Man Zhou?" the teacher went on, smiling.

"The needle might not be clean," said Man Zhou, looking up at Miss Chiew.

"It may have germs."

"The syringe is clean; don't worry," said the teacher, patting his back.

"How clean is it, teacher?" I chimed in.

Miss Chiew tipped her head slightly towards me and said, "Every needle is sterilized over a fire."

The word *fire* shocked the bejeebers out of me. *What would it be like to have a hot needle shot into my upper arm? Is there a Bunsen burner in the resource room? Is the dengue epidemic in Malaysia really so bad that everyone must have the injection? Can I say no to the injection?*

I found myself moving closer and closer to the fat nurse at the door. Fifteen or twenty restless pupils were yammering behind me within the corridor. The cacophony of their chatter made me all the more nervous. By the time I came face-to-face with the nurse, my pulse almost stopped. The dreaded moment had finally come.

I stepped into the resource room, my eyes roving around every corner. *Could I make an escape?* Several male medical assistants and female nurses were stacking piles and piles of injection kits on a long table. A wave of panic surged deep in the pit of my stomach. My legs buckled, and I staggered backwards. Sensing my uneasiness, a fair-complexioned, bob-haired woman, whom I gathered was a staff nurse, came up to me and said, "Calm down, *Xiaodidi*[4]. There's nothing scary about the injection." She took my hand in hers and led me gently to the equipment-laden table. Her words did not take the edge off my fear. To me, everything in the room smacked of doom. I would be injected by a fire-sterilized needle and suffer great pain!

The staff nurse told a young nurse to administer my injection. She took out a syringe and a small bottle of fluid from a kit. I wondered if it had been sterilized over a fire before I entered. *Will it be hot and painful? Where is the Bunsen burner?* My heart was

[4] Little boy(Chinese)

pumping so fast that I could hardly breathe. Fear ran down my spine as I saw the nurse uncap the bottle and insert the syringe into it. The fluid was drawn into the syringe as she retracted the plunger with her deft hand. Holding the syringe in one hand and a spirit-soaked cotton ball in the other, she said, "Pull up your sleeve, boy. I am going to inject you." The light of the fluorescent tubes on the ceiling glinted off the needle tip, making it appear even more frightening. I found myself shaking as I willy-nilly did what I was told. The nurse dabbed the wet cotton ball on my upper arm in a circular motion and said, "Relax. Don't get yourself tensed up."

Unable to hold my fear any more, I shouted no at the top of my lungs and shook her hand off my shoulder. I rushed headlong towards the open door, but a tall, quick-reacting male medical assistant blocked the way out with his outstretched arms. I wheeled round and almost bumped into the plump body of the staff nurse. I pushed her aside with all my might and ran towards the closed back door. A Malay nurse in a white headscarf flung herself forward and grabbed my left hand. I resisted furiously, and after biting her, managed to wrench my hand out of her grip. I ran around the room with four or five nurses chasing after me. Many pupils got out of line to press their faces against the windows, laughing and cheering.

My attempt to escape came to an end when a stout male medical assistant caught hold of my shoulders. Despite my struggle, he lifted me up effortlessly and plonked me down on a chair as if I were weightless. The others quickly surrounded me from all sides. I could hardly move a limb. I kept cursing in anger, saliva foaming at the corners of my mouth. No matter how I stamped my feet and flailed my arms, there was no way

I could get away from them. I buried my face in my hands and burst out crying.

"Leave the boy alone," said the staff nurse.

The grips on my shoulders and arms loosened at once. The staff nurse stooped down and circled her arms around me. She tapped the small of my back and whispered in my ear. "Don't cry. We will not cause you harm." Her motherly voice and hug had a gentle calming effect on me. I gradually settled into a quiet sob. She wiped my tear-streaked face with a soft piece of tissue paper and stroked my ruffled hair smooth. When I sobbed no more, she filled a plastic cup with water and gave it to me. Feeling unbearably thirsty, I finished it with a swig and almost choked on it. The nurse smiled and said, "Are you feeling okay now?"

"Yes," I answered.

"What makes you so afraid to receive the injection?"

"I . . . don't . . . want to be . . . injected by a fire-sterilized needle," I said through sob-induced hiccups.

"Who told you that?" The nurse's eyes widened in surprise. "There's no such thing." Her colleagues exchanged looks and grinned.

I shook my head, feeling too afraid to mention Miss Chiew's name.

"We use disposable needles. They are hygienic and convenient to use," explained the nurse.

"So the needle won't be hot?" I asked doubtfully, raising my eyes to meet hers.

"No, it won't," she said, giving me a reassuring nod. "Are you ready to receive the injection now?"

I did not know how to answer.

"Don't hesitate any more. Dengue fever is spreading very fast, and many kids have already been infected and admitted to hospitals. Your life will be safer if you receive the injection. Do you see how important it is to you?" advised the concerned nurse.

I nodded my understanding and let the staff nurse inject me. The injection was not as painful as I was expecting. It felt like a pinch, but for only a second. Nor was it hot. Guilt and shame crept up on me. What havoc I had caused in the resource room. I said sorry to the staff nurse and her coworkers. They smiled and accepted my apology. When I came out of the room, many pupils were pointing and laughing at me. My form teacher gave me a hard lecture. Miss Chiew shook her head at me. A few other teachers described me as silly. I was too emotionally spent to pay attention to them. I just wanted to get away from that room.

Thirty years have passed, and I still have a deep-seated fear of injections.

Being Hazed at The Teacher Training College

The moment Papa put the long-awaited letter from the teacher training college into my hand, I knew that the brightness of my future depended on its contents. Thrice I had been denied admission to the college and one more rejection would have crushed my confidence forever.

My hands were shaking with anticipation as I tore the envelope open. I was scared by the possibility of seeing the phrase "Regretfully, we inform you that you have not been accepted as a trainee teacher." It had taken me months to get over my sadness at the previous rejection. With trembling hands, I unfolded the letter and read it. The first line that greeted me was: "Please be informed that you have been accepted as a trainee teacher for the English course."

I could not believe my eyes and read the opening again. To my sheer relief, I had not misread the words. I erupted into joy. My dream had come true. The acceptance convinced me that I had not been wrong in choosing the teaching profession as my vocation.

"Papa!" I said in a burst of excitement. "Maktab has accepted me as a trainee teacher!"

"Praise the Lord!" said Papa, and made the sign of the cross. His eyes reflected his fatherly pride and perhaps relief too.

I wiped my eyes and said, "Ya, all glory and honour be to Him. He has answered my prayers."

"When should you register at Maktab?" asked Papa, in a voice full of concern.

I read the letter again and found that all newly accepted trainee teachers should register at the teacher training college on 1ˢᵗ July 1994, 8 a.m. to 5 p.m.

My head jerked up in shock. "Isn't today 1ˢᵗ July?"

"Yes," Papa replied.

"Papa," I asked, "what's the time now?"

"It's 11 a.m.," answered Papa. "Why? What's the matter?"

"I have to report to Maktab immediately," I gasped. "Registration is today!"

"Are you sure?" asked Papa.

"Yes!" I shouted impatiently.

I dashed into my bedroom and dug into my disorganized mess of personal files. I ferreted out all the required documents, put them in a large envelope, then I left for the college in a taxi that Papa had called.

The college was situated along Bakam Road, a twenty-five minute drive from my home. Facing a stretch of pine-fringed, sandy beach across the highway, it was far from the zest, vigor and stir of Miri town. When the taxi entered the college along the main driveway, stretches of well-manicured lawn hemmed us in on both sides. The grand assembly hall, the place where the registration of new trainee teachers was held, rose majestically from among trees and shrubberies at the far end of the road. The

hostels were located several yards behind the hall and I wondered what it would be like living a communal life with hundreds of fellow trainee teachers. On the way to the hall, the taxi passed two large tennis courts. Would I have an opportunity to play tennis during my training at the college? My heart was brimming with joy. Everything boded well for me; I was sure there would be nothing but fun and pleasant surprises in store for me in the college. I was so excited to be a part of all this. Finally!

I snapped out of my reverie when the taxi pulled up in front of the assembly hall. After paying the fare, I got out of the car and scurried towards the assembly hall. There was an inquiry counter on the left-hand side of the entrance. A girl and a boy in smart blazers were sitting there, casually chatting with each other. I approached the girl and spoke in English: "Good morning, I am a new trainee teacher for the English course. Can you tell me where I should register?"

The girl grinned and said, "Welcome to teacher training college. Enter the hall and proceed to the first counter on the right-hand side."

"Thank you," I replied.

As I was about to turn on my heel, the girl asked a question that made me stop in my tracks: "You are Lo Sin Yee, aren't you?"

"Yes, I am," I said, baffled. "How did you know my name?"

"Don't you remember me?" asked the girl, switching to Chinese.

I scrutinized her face, trying to recall where I had seen her. She had a short, wavy hairdo, and skimming her thin eyebrows were slightly tousled side-swept bangs. Her slanted eyes had a mischievous glint to them and her delicate nose and lips complemented her oval face. All of a sudden, I detected some

trace of familiarity in her face. Several years before, the face had been plumper and bordered by curly, shoulder-length hair. Though looking more mature and beautiful, she still carried the same air of cheerful ease.

"Are you Bong Lee Hui?" I asked.

"Yes, you are right," she replied, and turned to the boy next to her. "Sin Yee was my schoolmate at St. Patrick's. He's very good at art."

Her companion did not say a word as he sized me up from head to toe with a sly smile.

"Nice to see you here," I said, feeling embarrassed about Lee Hui's compliment. "How long have you been at this college?"

"I have been here for two and a half years," she replied. "I am graduating at the end of this year."

"That's great!" I said. "I hope I'll have no problem graduating."

"You won't, "Lee Hui said, "as long as you put your mind to it."

"Lee Hui," the guy cut in, "what an arrogant friend you have."

"You are right," Lee Hui said. "He flaunted his knowledge of English before speaking Chinese to me."

"You misunderstood me," I explained earnestly. "I thought it was polite to speak in English. Besides, I did not recognize you at first."

The two exchanged glances and dissolved into laughter. Embarrassed, I took my leave and headed to the assembly hall.

There were many counters inside the hall. Each was made up of a pair of mentor and mentee desks, which had been positioned to face each other. I had no problem getting to the English counter. The mentors were an elegant Punjubi lady and an austere-faced Chinese lady.

"Are you a trainee for the English programme?" asked the Punjubi lady.

"Yes," I said.

"Give me your identity card," demanded the Punjubi Lady.

I did as I was told and, with my identity card in her hand, she scanned a list of names.

"You are not in my class," declared the Punjubi lady, passing my card to her neighbour. "You are in Madam Sheila's."

"Thanks."

I moved over and stood in front of Madam Sheila, the Chinese lady, who looked at me icily over the rim of her glasses. "Sit down," she said.

A sunlit pattern fell across me from the upper portion of a stained glass panel on the wall as I sat down.

"Your year of birth is 1970," said Madam Sheila. "Are you twenty-three years old this year?"

"Yes," I said, nodding.

"You are twenty-three, one of the oldest trainees on my mentee list," said Madam Sheila. "How do you feel as an older trainee?"

"I will try my best to do well in my studies," was my awkward reply.

"Show me your academic certificates," demanded Madam Sheila.

I removed all my documents from my envelope and put them in a pile on Madam Sheila's desk. A few, I noticed, were frayed at the edges.

"How disorganized you are," said Madam Sheila, flipping through my documents. "You should have handed me one whole file with every original certificate on one side and its photocopy on the other."

"I am sorry," was my shameful reply.

"Not only that," said Madam Sheila, glaring at me, "your documents have not been certified yet. How remiss of you!"

64

"S-s-sorry," I stammered. "I did not read the acceptance letter properly."

"As a future teacher," said the lecturer, raising her index finger for emphasis, "you ought to have read through the instructions properly. Today's occasion calls for good self-discipline. Being observant of instructions is part of it. And you're not even dressed properly."

"You should have worn a tie, a long-sleeved shirt and a pair of slacks," explained the Punjubi lecturer.

I bowed my head in shame. I must have looked sloppy in my faded T-shirt and well-worn jogging pants. I wanted to explain that I had only received the letter two hours ago, but I remained silent.

"Where is your luggage?" Madam Mitty asked.

"I didn't bring anything with me," I said.

Tapping her desk, she gave me a stern look and said, "All new trainee teachers are to move into the hostels this evening. Didn't you know that?!"

The Punjubi lady shook her head and said, "Sheila, what a mentee you've got!"

Madam Sheila snorted, "Swaran, it seems that all the bad ones end up coming to me."

I kept on apologising effusively, wishing I could burrow into a hole to hide myself.

"Now let's see what you got for English," said Madam Sheila, looking at my SPM certificate.

"What did he get?" asked Madam Swaran, a hint of contempt in her voice.

"Only a C4," said Madam Sheila, smirking, "which is poor by Malaysian standards. Not many of my mentees obtained an A1 and A2."

"I've been more fortunate," said Madam Swaran, gloating. "Most of my mentees scored an A1 and A2 for their English."

"Alas!" exclaimed Madam Sheila." Before teaching my mentees how to teach, I have to polish their English first."

It was very hurtful to be labeled as a poor student and I felt they were being unfair. I had continued to read voraciously several years after leaving school and I believed that my current proficiency was much higher than before.

"Over the years, I have seen many trainees like you struggle with their teaching . . ." Madam Sheila remarked, her voice trailing off. Something on my certificate seemed to have caught her attention, sidetracking her from focusing on my English grade. She smiled at me and said, "You scored an A1 in history. Why don't you change your option to history?"

Madam Swaran nodded and stated, "Sheila is right. I think you can do a better job as a history teacher. Not many people can handle the teaching of English well."

Madam Sheila added, "If you make the switch, you will be sparing us a great deal of trouble."

I shook my head and said, "No, thanks. Being an English teacher is my ultimate goal."

Rolling her eyes, Madam Sheila returned my certificates to me and said, "Now go home and get a Grade A government officer to certify your documents. Then come back here and give everything to me."

With a heavy heart, I took a bus home. Papa could not believe his ears when I told him about my negligence. After changing into appropriate attire and packing my clothes into a luggage bag, Papa took me to the workplace of a government officer friend. I had all my documents certified there, then I took a taxi back to the college. Having submitted my documents to

Madam Sheila, I proceeded to the Chinese community counter to sign up as a Chinese Club member. There were two girls at the counter, one petite and the other tall. They gave me a form and I filled it out with my details.

The petite girl read my form and said, "According to what you have filled in, you like singing."

"Yes," I said, mustering a smile.

"Entertain us! Sing us a song," requested the other girl.

I blushed, mumbling my reluctance.

"Come on," coaxed the tall girl. "You are going to be trained as a teacher. Don't feel shy about singing in public."

"May Ping is right," said the petite girl. "You should do your seniors' bidding. Sing us a song."

Having no choice, I cleared my throat and sang a Chinese folk song.

> "I'm traveling in a skiff across a wide sea,
> The azure sky and the turquoise waters are my friends,
> With the aid of the gentle wind I rowed my boat
> Towards the merging point of the sky and the sea
> The seagulls fly above me, singing a song of courage
> My spirit is soaring high among the clouds
> All my worries disappear beneath the undulating sea . . ."

The two girls clapped their hands, cheering, "Bravo! Bravo!" and a smattering of applause also rose from the neighbouring counters.

Raising her thumb, the tall girl said, "You have a rich, powerful voice."

The petite girl nodded and said, "Madam Chong Siew Lin will be glad to have you as a new choir member."

"Thank you," I said, grinning from ear to ear.

I said goodbye to the girls and lugged my bag in the direction of the warden's office, which was housed in a corner of the administration block. Halfway down the roofed corridor, I was waylaid by a fat Chinese girl, a short boy, a dark boy and a beady-eyed boy.

"There he is," the fat girl said in Malay, pointing her finger at me. "The cocky one!"

"Where do you think you're going?" questioned the short boy, blocking my way with outstretched arms.

"I'm going to collect my room key," I said. "Can you let me pass?"

"Wow!" the short guy exclaimed theatrically. "See how arrogant he is?"

Clucking his tongue, the dark guy said, "He looks down on us. He thinks he's high and mighty."

Their noise attracted the attention of quite a number of students, who then stopped to look at us.

"What do you want from me?" I asked.

The short guy bellowed, "Maktab is such a noble place. It is not for cocky people like you!"

The girl said, "We are all your seniors. You should respect us!"

Bearing down on me, the beady-eyed guy said, "You bastard! Don't you know that it is polite to call us senior brothers and senior sister?"

I staggered backwards and said, "Leave me alone, please."

My plea was met with jeers and catcalls.

"Ha! Look at that coward," said the fat girl. "Groveling shamelessly to us like a sissy."

I felt so insulted that I was speechless.

The short guy growled, "Who are we? Where is our greeting?"

"You a-a-are . . ." I stammered, my tongue dry and my breaths rasping against the walls of my lungs.

"Louder!"

Controlling the tremor fanning out from the base of my spine, I said, "Good afternoon, senior brothers and senior sister."

"Kneel down!" roared the short guy.

I hesitated. Many onlookers were goading me to comply.

"If you don't," sneered the fat girl, "we won't let you go."

My ego was disintegrating.

I kneeled down at their feet one by one. All the onlookers roared with uncouth laughter. Among them were Bong Lee Hui and a few male lecturers. They were thrilled by how the four students had browbeaten me into submission. Instead of watching the show, the lecturers could have used their authority to stop the senior trainees. Why didn't they come to my rescue? Was Lee Hui the one who had told the bullies about my supposed arrogance? What had motivated me to become a trainee teacher? Nothing could erase the indignity of being publicly shamed.

When I eventually got my room key, I rushed into the hostel and was relieved to find that I was the only occupant in my room. My roommate had not yet registered and I selfishly hoped that he would not come. My room was nondescript and dusty. A window could be found in the northern part of the room, which afforded a view of a baseball field. There was a bed against the left wall and another against the right. After unpacking my belongings, I sat huddled up on my chosen bed, the one on the right. Recalling what had happened to me, I buried my face in my hands and burst forth into a passion of sobs. Why had I let

the seniors torment me in such a humiliating manner? Why had I yielded to their will? Where was my self-worth? Why was I so weak?

"Crying is not a sign of weakness," Mama's advice came unbidden into my mind. "It is a good way to unburden you from sorrow. Through tears, courage arises and we will be armed with greater tenacity to face tomorrow."

After crying, I felt as if a great weight had been lifted off my shoulders. I got off my bed and crossed myself. I was calmer and more collected, but felt dirty and sweaty. The heat of the midday sun was overbearing. I decided to take a shower to refresh myself. After stripping to my underwear, I walked into the communal shower room with a towel wrapped around my waist. With so many slim, average-built boys around me, my self-consciousness got the better of me and I felt bashful about my large body. I took a deep breath and sucked my stomach in to make it appear less paunchy. My 220-pound body was like a ball of flesh. I felt like a hippopotamus roaming among a cluster of ducks and chickens. All sorts of negative feelings began to overcome me.

"You fool! Why are you feeling negative again?" I muttered inaudibly to myself. "Do not let this trifle defeat you." The self-chastisement took the edge off my embarrassment. After all, everyone in the shower room was half-naked like me.

It took me nearly fifteen minutes to get into a shower stall. There were simply too many people waiting to take a shower. I scrubbed myself as quickly as possible. Gone were the days when I could dillydally in my shower room with time to spare. In college, every second was precious. I finished my shower within a few minutes and my place was taken by a Malay boy. Next, I washed my clothes. To save time, I used only a little washing powder. I then pegged all my washed clothes on the congested

drying lines outside. I managed to catch some shut-eye in the private comfort of my room before queuing outside the hostel for dinner.

While marching to the dining hall with the other new trainee teachers, a few seniors hectored us. With the previous harrowing experience fresh in my mind, I greeted them subserviently. Some trainees had to submit themselves to the humiliation of sniffing shoes and slippers based on the seniors' demands. "We are your super seniors," a barrel-chested, bespectacled senior called Roland said. "Anything belonging to us deserves respect!" He was large by Malaysian standard, standing at six feet one. I found him loathsome. He and his accomplices were typical sadists whose only motive was to sate their craving to humiliate the weak. One cannot shape a noble character through bullying. Anything done out of spite spawns vindictive hatred.

The first rule in the dining hall dictated that everyone should enter the building barefoot. Many slippers, sandals, flip-flops and various shoes were scattered in motley confusion outside the sliding doors. We lined up, waiting for the kitchen hands to scoop rice and dishes onto our trays. The spicy aroma of curried chicken filled the entire hall and a deep pang of hunger stabbed me in the stomach.

When I reached the food distribution counter, a scrawny male kitchen hand portioned out a hillock of rice, a mere sliver of chopped chicken thigh and some mustard greens onto my tray.

I protested, "Why did the girl before me get a larger chunk of chicken?"

The male kitchen hand said, "You are so big. You don't need that much chicken."

"That's not fair," I groaned.

"Stop complaining," said the man. "I can give you more mustard greens."

With that, he scooped a generous amount of mustard greens onto my tray. The vegetable was yellowish, limp and mushy. I hated to be fobbed off in that manner.

Boys and girls had to dine in separate territories. Any male seen sitting with girls would be harangued and relocated to a different table. The seniors also warned us against sitting according to racial groups. Hence, each table consisted of multiracial trainees. Having exchanged greetings with the boys at my table, I shoved some mustard greens into my mouth with the urgency of hunger. I almost vomited; it was not only overcooked but greasy, salty and gritty like sand. There was also an unpleasant metallic taste to the leaves. While chewing, something cracked in my mouth. I spat it out and saw a tiny, broken snail. It made me so ill with disgust that I decided to stop eating the dish. I tasted the chicken but was turned off by its blandness. The morsel of meat that came off the bone had no succulence and firmness at all. How I missed my Papa's cooking! If I were at home, he would surely have cooked a delicious dinner of porridge, stir-fried spinach and steamed minced pork patties. The only tolerable food in the dining hall was the rice, which, in a bid to quell my hunger, I gulped down with the help of some water.

"Terrible meal," remarked a peeved Melanao. "It reminds me of slops." His exaggerated comment elicited affirmative nods and knowing chuckles around the table.

"I could cook far better than this at the age of ten," a sturdy Bidayuh boy named Christopher said to me. I gave him a wry smile and continued conveying the rice to my mouth. After eating, I went to wash my tray at the back of the dining hall.

I had to watch my step because the floor was wet and slippery. Like me, most of the trainees had consigned the mustard greens to garbage bins. Many kitchen hands shook their heads and berated us for being too picky about food. When I came out of the dining hall, darkness had descended and was almost consuming the last rays of twilight. My enthusiasm for college life had been reduced to a flicker. I was desperate for the warmth of my home. God, was it a sin to complain nonstop? All my attempts at self-motivation had failed.

"Keep your chin up, Tai Tai," I said to myself, with a sigh.

There was an assembly for all trainee teachers at 7 p.m. that night. It was held to welcome all newcomers like me. The hall was almost filled to capacity. Stepping into the place for the third time, I was less nervous and was able to study the building in detail. The interior was fully lit, giving the tall stained glass panels an iridescent look from the outside. Glossy wainscoting ran parallel below the glass panels, its flow interrupted by four side doors along the left and right walls. The fanlight on top of each door looked like a half moon, which reminded me of a Chinese proverb: "When you tilt your head up, you see the moon. When you bow your head, you think of your home." I wondered if all the new trainees were as homesick as I. The moon also represented our common dream. To pursue it, we had to leave the comfort of our homes and be exposed to the hostility of the outside world. The thought of this made my eyes a little moist. I wondered if other new trainees shared my sentiment. We all sat according to our majors, directly facing the well-decorated stage. Along its octagonal edges were blue cloths that had been folded and pinned in an overlapping pattern. On the backdrop were seven gold-dusted words that read: "Welcoming Ceremony

for July Intake Trainee Teachers." The stage had a look that was grand and formal, albeit a little gaudy.

When the master of ceremonies announced the arrival of the dean with her entourage of lecturers, we rose and gave them a warm welcome. The dean, Puan Rokiah Haji Omar, looked dignified in her light purple traditional Malay headscarf and gown. She was my former principal at SMK Lutong, the school I had attended for six years before going to St. Patrick's. I was glad to be her student again.

After a brief prayer session, Puan Rokiah was invited to give a speech. She began with positive, encouraging words: "All praise and glory be to Allah the Almighty for the presence of five hundred new trainee teachers in this evening assembly. Welcome to the Maktab Perguruan Sarawak family. You are all future teachers of whom we are proud." At that very instant, clapping erupted throughout the hall. When it subsided, the dean went on to say that there was nothing as noble as being a teacher because his or her mission in the world was to educate the younger generation to become future leaders.

"We are all servants of Allah," said the dean in her well-articulated voice. "We help Him to counsel the trouble-hearted and to direct the disorientated towards the right path." Puan Rokiah also advised us to respect the lecturers. "They are highly qualified educators who are concerned about your well-being," said she. "With their unequivocal commitment, they drill and guide you to be qualified teachers. Please give them your full cooperation."

Madam Sheila and Madam Swaran sat in the front row on the stage, looking incomparably distinguished with the air they exuded. Many of the lecturers seemed blasé about the whole affair. They must have attended too many functions like this.

When the dean's speech was over, she walked down the aisle and left the hall with the lecturers in her wake. Elated, motivated and with high expectations, I looked forward to the next session. The prefects, however, forced us to stand and cup our hands behind our ears throughout the speeches of the headboy and the headgirl.

"By standing like this, you will be more alert and attentive," said the headboy. Of course, it was easier said than done. The posture gave us extreme soreness in the shoulders and elbows. If we lowered our arms under the strain of pain and tiredness, other prefects would stride over and chide us for being "disgracefully slack". I wondered if the seniors themselves were able to hold the posture for the same length of time as we did.

"Based on my observation," continued Hamzah, the headboy, in a cocksure way, "many of you are arrogant. What you don't know is that there are many people in this college who are more capable than you are. Hence, we will conduct 'hazing' on you. Our main objective is to purge you of all undesirable qualities in the first week of your training at this college."

I grimaced at the words "hazing" and "purge". They caused a feeling of inexorable doom to well up from the pit of my stomach.

"Hamzah was spot on with his observation," said Siti, the headgirl. "Hazing is a rite of passage for all freshmen. The seniors, be they prefects or ordinary trainees, have the right to discipline you. None of you can question our authority because we have been empowered by the dean to instill the values of obedience and humility in you. You have to obey us whether you like it or not!"

I did not like what she said. It was apparent that every Tom, Dick and Harry could haze us. What madness! Couldn't the

dean see that irresponsible seniors might abuse and usurp the power? I had already had an awful encounter with some fiendish seniors earlier in the afternoon and their so-called corrective action had been based on nothing constructive at all. Was hazing a trend to discipline freshmen in all Malaysian colleges and universities? Did it serve any educational purpose? It should be excised at its root!

On our way back to the hostel after the assembly, a knot of raucous ruffians let fly a torrent of abuse at us. They called us knuckleheads, twits, prigs, wimps, mother-ridden kids and the like. A trainee from Pahang did not greet a curly-haired senior and he was pushed down on all fours. Refusing my help, he scrambled to his feet with pain in his eyes. Under the glare of the lamppost, pinpricks of blood swelled on his palms. The gravel along the crudely paved ground must have caused the cuts and abrasions. Pale from the restraint of anger, he bowed to the senior and offered him a servile greeting. A smug smile spread across the monster's face and he let him go. I could not help muttering a few curses at the senior trainee. He had gone overboard. He rankled me with his flagrant disregard for the injured boy's feelings.

All of us were told to sleep at 12 a.m. However, the senior prefects were bent on making the night a hellish one for us. We were awakened several times at ungodly hours by the wails of loud hailer sirens and the percussion of banging and kicking on our doors. The culprits ordered us to gather outside the hostel and do silly calisthenics, such as pushups and hopping, in the cold of the night.

At 3 a.m., the headboy promised to grant us uninterrupted, peaceful slumber. He told us to wake up before seven the next morning. There would be a mass aerobics session on the

basketball court before breakfast. I heaved a sigh of relief and schlepped back to my room. Before turning in, I said a prayer to God:

"Lord, I am tired and overwrought. I have experienced the whole gamut of emotions today. I can't bear all this bullying. I feel as if I am walking along a trail full of thorns and snares. I am too weak to defend myself. People trample on me at will, treating me like dirt. Be the master of my thoughts and actions, O Lord. I have just crossed the threshold of the teaching profession and I don't want to quit and disappoint my parents. Give me a steely determination and a persevering heart to complete my three-year training here. Unto you I submit my whole self. Amen."

Lesson from My First Day As A Teacher

On my first day as a teacher, I missed assembly.

I loathed myself for this negligence. If I had been calm and organized, I would not have gotten myself into such trouble. Three days prior, on registration day, I had struggled with a group of parents who were in a hurry to pay the school fees. Gripped by panic, I had forgotten to write receipts over the carbon paper I had brought, and I ended up having no copies of the payees. To add salt to the wound, I accidentally gave some parents excess change, and none of them had bothered to return it to me. On the day school reopened, I told Mr Ng, the senior assistant at my school, about the problem. In response, the stocky man gave me a long telling-off—the cause of my inadvertent absence from the first assembly.

"W-what should I do about the excess change I g-gave them?" I asked in a stuttering voice that teetered on the brink of tears.

"You have no choice but to pay it out of your own money," Mr Ng said.

My heart sank. The compensation would make huge inroads into my meagre savings, which I could ill afford as a new teacher. I had not realized that the first day of my life as a teacher would be riddled with so many problems, and the day had hardly begun. A week prior, I had been full of starry-eyed notions about accomplishing my job as a teacher; now I felt like a deflated balloon, gloomy and dejected with a ruptured ego.

"Cheer up, young man!" said Mr Ng. "Be thankful that you don't have to pay too much. There will be more challenges awaiting you as you progress through your career."

"I will be more careful next time," I said, trying to sound as apologetic as possible.

By the time I came out of Mr Ng's office, assembly was already over. I stood in a daze in the corridor, watching swarms of students walking in different directions as they headed back to their classrooms. I spotted a fellow new teacher among the crowd and walked up to him hastily.

In a worried voice, I asked, "Gilbert, was Mr Peter looking for me during assembly?"

Gilbert frowned and said, "Yes, the principal called out your name twice during the introduction of new teachers. Where were you?"

I tapped my forehead and groaned, "I'm damned, I'm damned."

Turning around, I headed back to the staffroom. I was beside myself with panic and nervousness. *How could I have been so careless? The principal would surely have a low opinion of me. Should I go to his office and explain myself?*

I had trained for three years as a diploma-level teacher at Maktab Perguruan Sarawak. During my stint at the college, life had been a secure, predictable routine—I had never been

exposed to any trouble, just minor hiccups. Everything had been well planned in the college, and I had enjoyed swotting on teaching pedagogies and writing good lesson plans to impress the lecturers. Having no head for figures, I always tried my best to avoid the tasks that required the use of calculations. It was this weakness that now landed me in big trouble. My equilibrium was totally disrupted, I felt lost and ashamed. I was no longer in the mood to enter my first lesson.

I sat down at my desk and buried my head in my hands, attempting to blank out my troubled mind. If I could just relax and calm myself with a cup of hot chocolate or some ice cream. How I wished I were at home licking my wounds. I wanted to tell my father how frustrated and disappointed I was with myself. He had always been willing to lend his ear to my troubles. Right now I felt helpless amid my new colleagues, and they all seemed cold and unfriendly, too. Surely Mr Ng would tell them about my blunder. They would probably have a good laugh over my careless mistakes and missing assembly!

"Are you Mr Lo?" a girl's voice reached my ear.

I raised my head from my arms and shook away my drowsiness as I met the gaze of a tender-faced, bespectacled girl.

"I am Mr Lo," I replied. "May I help you?"

"I am the monitor of form 2B," said the girl. "You are late for our English lesson."

Panic struck me as I looked at my watch and realized that I was fifteen minutes late for the eighty-minute lesson. When had the bell rung? I must have fallen asleep while trying to rest my mind. Now I was really in trouble. This was horrible!

"Is your class noisy?" I asked, getting my materials. "I hope you didn't disturb the other teachers."

The girl nodded, ashamed. "Madam Wong of 2A asked me to look for you in the staffroom. Our noise was disturbing her lesson."

My heart sank. Madam Wong was the head of the English department, a fierce looking woman. She would be observing me in a few days. *Why do I keep getting into scrapes?*

When I reached the classroom, it was surprisingly quiet and I began to relax until I saw Madam Wong standing in front of the students, looking at them sternly. A stab of guilt shot through my chest, and I could feel my cheeks blush. Without a word, Madam Wong glared at me and walked out of the classroom.

An excited murmur rippled through the classroom immediately.

I cleared my throat and said, "Good morning, class."

The students rose and chanted, "Good morning." I smiled and asked them to sit down. The class consisted of thirty-four students. I was told that it was one of the best classes of secondary two.

"I'm sorry for being late," I said. "I am Mr Lo, your English teacher for this year."

"I see," a slant-eyed boy drawled and rubbed his eyes. The whole class erupted into laughter.

"Be quiet," I said, raising my voice. "I am happy to be your teacher. From now on, we are friends."

I tried to keep as calm as possible, reminding myself that in order to establish good class control, a good first day impression was very important. Unfortunately, being so late did not exactly help my cause.

"Where are you from, teacher?" a long-haired girl asked.

"I'm from Miri," I replied.

"You did not understand my question," said the girl. "Where did you graduate from?"

I was a little miffed by the girl's impertinence. Trying to sound unintimidated, I told her that I had graduated from the Sarawak Teacher Training College.

"Oh, that institute on Bakam Road," a dark-complexioned boy sneered. "So you're not a degree-level teacher?"

"For now I am just a diploma-level teacher. But I'm planning to further my studies in three years."

"Does it mean that you are not good enough right now?" the boy asked derisively. The whole class roared with laughter again.

The boy's remark hit a raw nerve in me. Ever since I had arrived at the new school, I felt out of place. Most of my colleagues were degree holders, and my diploma seemed miniscule compared to theirs. Anger was slowly building up within me. Why were the students treating me with disdain? Did they do this with all new teachers, some rite of initiation? Their rudeness did not altogether tally with my presumptions about the naivety of students. Was this the cruel reality of teaching at a secondary school? I had done my practicums at two primary schools before, and the children there had not been as judgmental as this group. *What should I do to make them look up to me?*

Wanting to grab their attention, even startle them, I hit the teacher's desk with my fist, and the students fell into stunned silence. In a loud voice, I said, "Class, as students, you should be civil to your teacher. I went through a three-year training course and am therefore quite qualified to teach you. Take out your exercise book now, and let us write a composition."

Many groans erupted. A bob-haired girl raised her hand and asked sweetly, "Mr Lo, aren't you interested in getting to know us? You haven't asked us to introduce ourselves."

"Thanks for your reminder," I said. "Please stand up and introduce yourselves in English."

One by one, the students stood up and introduced themselves. I walked down the length of each sitting row as I listened to their introductions. A pimply boy refused to stand up when it was his turn to introduce himself. When I asked him to stand, he responded that it was childish to introduce himself in that way.

"Come on," I persuaded. "Be confident. Draw yourself up to your full height."

"Aye, aye, sir." The boy rose and looked down at me. He stood a good three inches above my five-feet-eleven frame.

I involuntarily took a step back. A few students giggled in amusement.

"I am Chen Foh Ming. I am fourteen years old. I like playing basketball and reading comic books. Are you happy now, teacher?" asked the boy in a pompous, insolent tone. "Thanks for introducing yourself," I said sarcastically. "Don't knock yourself out with your negativity."

When the introductions were over, I asked the students to write a composition about a picnic. I could have asked them to write a simple composition about themselves, but I was desperate to assert my status as a competent teacher. I gave them a list of sample sentences with ambitious words and phrases (which I wrote on the blackboard). I was thrilled when some students asked me for the meanings of some idioms. I thought it would be an opportunity to finally redeem my pride.

"Teacher, one of your sentences is wrong," a girl named Siew Mit said.

"Which one?" I asked.

"The third one from the bottom," Siew Mit pointed out. "The one that reads, 'We had fun without a care for the world.'"

"It's correct," I insisted.

"No, it's not," she said. "It should be 'without a care *in* the world.'"

The girl's correction struck me like a slap in the face. She was right. *What a stupid, careless mistake!*

The class booed as I made the correction on the blackboard. I could feel the throb of the arteries in my temples.

"Silence!" I barked again. "Anyone is prone to making mistakes. The most important thing is to learn from them."

My advice fell on deaf ears. The raucous mockery only stopped when the monitor threatened to call Miss Lee, the school disciplinarian, to the classroom.

I sat moodily at the teacher's desk, waiting for the students to finish the composition. But they made little progress with their writing.

When the bell rang, only twelve students handed in their exercise books. In frustration, I said, "Most of you were not serious about writing the composition. You spent too much of your time talking and dreaming. Please hand in your books by 12.40. I won't be accepting no late work!"

"Teacher," a student named Mun Cheong said, "the word *no* is not necessary in your last sentence."

The class broke into a frenzy of laughter. I hated myself for making the uncharacteristic error and made an ignominious exit from the classroom.

Remorse came over me as I trudged downstairs. I had a bad habit of making silly grammatical errors. Despite my constant efforts to be a good speaker of English, my sentence construction always went haywire when I was under pressure. There was simply no way to undo the damage.

Wearily, I shuffled back to my desk in the staffroom and felt disconsolate as I slumped into my chair. The staffroom was filled with the chatter of teachers boasting about their good class control. Their cocksureness irritated me.

After a few minutes, Madam Wong walked into the staffroom and complained loudly, "What chaos, what chaos!"

"What's wrong, Wong?" a Malay teacher named Fauziah asked.

"I had a hard time teaching in 2A just now," Madam Wong said. "The class next door was simply too noisy."

"Was there a teacher in the classroom?"

"Yes, a young teacher," Madam Wong said emphatically. "Only God knows what he was doing with the students."

I cringed inwardly with mortification. Obviously she was referring to me. Didn't she know that I was in the staffroom?

A teacher named Madam Tang chuckled and said, "Young teachers have always been too proud to seek advice from experienced teachers like us. When everything turns upside down, they blame the students for being disobedient."

"You're right," agreed Fauziah. "Good teachers produce good students, and bad teachers produce bad students."

Madam Wong put her book on her desk and said, "I always remind my students of the dos and don'ts of my lessons. They never dare to mess with me."

Fauziah nodded and said, "I am like you. I make sure my classroom is clean and everyone is sitting on his or her chair before I start teaching."

"I have such a headache right now. I should head to the canteen to fill my stomach, too" Madam Wong said. "Anyone want to join me?"

Several senior teachers left with her. Not one of them looked my way or even acknowledged my presence.

I felt very bad as I contemplated my first day, my first lesson—a disaster. I took a steamed bun from my plastic container and ate without relish. Half way through eating it, I lost my appetite. Suddenly, a male colleague came up to me and asked, "Mr Lo, are you free now?"

"Yes, I am," I said. "I'm free until 11.30."

"The principal wants to see you in his office," said the fellow. "You better go immediately."

I could feel the blood rush to my head. What miserable luck! Now I was in serious trouble. I put the half-eaten bun back into the container and dragged myself to the principal's office.

The office was ajar, and the principal was reading a newspaper at his desk. I knocked on the door and asked, "May I come in, sir?"

"Yes," said the principal without looking at me.

I entered the office and positioned myself in front of him.

"Mr Lo," said the principal, "I want to know why you were absent from assembly."

I bit my lower lip and said, "Sorry, sir, I had some trouble with the collection of school fees. I told Mr Ng about the problem, and it took us a long time to settle it."

"What a lame excuse," chided the principal. "You shouldn't have put your matter above assembly. If a teacher is missing, it sets a very poor example for the students."

"I'm sorry," I said, feeling deeply ashamed of myself.

"And who is the head of the school," the principal continued, "Mr Ng or me?"

"It's you," I said.

"He has no right to stop you from attending assembly," the principal said. "I am the head of this school, and it is compulsory for all teachers to attend assembly. Is that perfectly clear?"

"I'll never do it again," I promised meekly.

"Remember," said the principal, "never take school matters into your own hands."

"I won't."

"As a new teacher, you should always be at my beck and call."

"I will."

"Please sit down," the principal said. "Let's talk about other things."

"Thank you, sir."

The principal looked me squarely in the eyes and said, "As a new secondary school teacher, what do you know about the national education policy of Malaysia?"

"Its aim is to produce students who are intellectually, emotionally, physically, and spiritually balanced," I said.

"Good. What about the vision of our school?"

I bowed my head low and admitted that I could not remember it. Too much was running through my mind right now.

"That's very bad," said the principal as he smirked. "As a St Joseph teacher, you should be well-versed in the school's vision."

"I'm sorry," I uttered.

"Now, recite the five tenets of KBSM, Malaysian national curriculum for secondary schools."

My blood ran cold. I had read about the five tenets before, but I could not remember anything now. It was a wonder I could remember my own name.

"Sorry," I said nervously. "they slip my mind at the moment."

"How can you teach without knowing anything about the tenets?" the principal asked. "You should be ashamed of yourself."

I was so ashamed that I became speechless.

"Teaching is a noble profession," the principal said sternly, "but students aren't predisposed to learning from ignorant teachers. Is that perfectly clear?"

"Yes," I replied, hurt by the acidity of his remark.

"When I was your age, I read extensively," the principal continued. "Education periodicals and circulars are important reading materials. They keep us up to date with the current issues of education."

"I will read all these to widen my knowledge," I replied.

"What did you do in your lesson just now?" demanded the principal.

I grimaced as I recalled what I had done in that first disastrous lesson. Had he heard something about it?

"I asked my students to write a composition about a picnic."

"What else?"

"We discussed about the meanings of some idiomatic expressions."

"Can you repeat what you just said?" the principal asked.

"Well, we discussed about . . ." I began.

"What kind of English teacher are you?!" the principal asked with a scowl, tapping his desk with a pen. "It is wrong to say *discuss about*. The word *discuss* itself means *talk about*!

"I'm sorry," I apologized. "It was a slip of my tongue."

"No, it wasn't! Just admit that you didn't know," the principal said severely. "Your English is atrocious."

I could feel a lump in my throat. I had never been insulted that way.

"Most of our students speak good English," the principal said proudly. "How can you convince them of your credibility if your English is bad?"

"I will try my best to improve my English," I mumbled, my mouth dry and tasting bitter.

"Say again," the principal demanded.

"I will . . ." I started to say.

"Can't you speak louder?"

I took a deep breath and repeated what I had said in a louder voice. The principal smiled maliciously and handed me a piece of paper.

"This is a Malay article on what makes a good teacher. Read it aloud to me."

Trying as hard as possible to collect myself, I read the article. Much to my despair, the principal did not seem to be paying attention to what I was reading. He kept flipping through a book while making strange guttural sounds that were exceedingly annoying. When I finished reading the article, he asked me to give my viewpoint on it. He made more guttural sounds as I presented my personal interpretation of the text. Disturbed by his snubbing, I made some grammatical slips and stumbles. The principal kept shaking his head scornfully.

"Of all the newly posted teachers, you are the worst. What do you mean by *success correlates to hard work?* The correct preposition is *with*! Why do you keep using the conjunction *besides*?"

My face burnt with humiliation. He seemed to enjoy rapping me on the knuckles. I would have cried if I were a girl. In spite of his small stature, he made me feel like a naked baby and he seemed to enjoy it too.

One hour passed, and in ten minutes, I needed to go to a double-period lesson with a form 1 class. With no time to review my notes, I told the principal that I had to go, and he asked me to first fill out a form. I hurried to fill out the form and took leave of him. "Wait, Mr Lo, you haven't filled in your identity card number," the principal said as he rushed out of his office with the form in his hand.

"Sorry, sir," I replied, and I took the form from him and filled in my number.

"Careless boy," the principal said, and caught me off guard by pulling my right ear lobe.

I gasped in pain, and a cackle of laughter rang out behind me. A few students had witnessed it while walking past the office.

My blood was boiling! I fought very hard to maintain my composure. He gave me a look of rebuke and walked back to his office humming "What a Friend We Have in Jesus." I rubbed my burning ear and cursed under my breath. Feeling bitter over the whole episode in his office, I strode down the corridor in the direction of the form 1 classroom. I blinked back angry tears as I prayed very hard for God's power to quell my tumultuous emotions.

The students greeted me in unison when I entered the class. I was their form teacher. They were new to the school and knew they had to behave themselves.

Remembering the senior teacher's advice, I briefed the students on the dos and don'ts of my lessons. And then I asked them to introduce themselves to me. Thankfully I did not encounter the trouble I had experienced in my previous lesson.

The lesson proceeded, and I divided the students into groups for a discussion on the topic: What will happen to us ten years from now? I phrased my instructions carefully to avoid

making any grammatical errors. I gave them twenty minutes to complete the work. When the allotted time was over, I asked the representative of each group to present what he or she had discussed.

As the students presented their work, I tried my best to stop thinking about all the previous unpleasant incidents. *I've made a lot of blunders, and it would not be fair to allow my foul mood to bring more shame into my life.*

When the presentations were over, I asked the students whether they enjoyed the activity. I felt that I had done a good job.

Quite a number of students replied, "Boring."

Their words dampened my spirits, but I eked out a smile and said, "It's okay. In our next lesson, you can make suggestions about what we can do."

"Teacher, why don't we play language games?" an Indian girl named Vanessa suggested.

"We can listen to a song and write down the lyrics," one plump Chinese boy said.

"We can do a sketch," one Malay girl said.

"Good suggestions," I said in praise of the students. "We will do all these activities. Just give me time."

The students smiled, and for the first time that day, I felt very happy.

The final bell rang, and the students bade me goodbye cheerfully. They thronged out of the classroom boisterously, eager to go home. As I made my way back to the staffroom through the student-filled corridor, two girls from form 2B approached me.

"Teacher, are you still angry with us?" a girl named Lee Fen asked.

"Do you think I am still angry?" I replied.

"Teacher, please be patient with us," the other girl, Karen said. "Even though many of us made fun of you, I like the way you taught us."

"So did I, teacher," said Lee Fen.

Touched by what I had heard, I thanked them. Maybe there was hope for me yet.

When I returned to my desk, I was surprised to see Madam Chong, one of the most senior teachers at the school, place a packet of Chinese vegetable dumplings on my desk.

"Mr Lo," said Madam Chong, "I made some dumplings with Madam Foo during our free periods. I'm giving you some for lunch."

"Thank you," I said.

"How was your first day of teaching?" she asked.

I shook my head and said, "Not so good. I was so nervous that I made some silly mistakes."

I had no idea why I was being so frank with her, but she reminded me of my kind mother, who was away working in Brunei to support my family.

"It's okay," Madam Chong said sympathetically. "I, too, have my own share of blunders. Do what you think is best for you and your students, and you will get a lot of satisfaction."

"I will try my best," I said.

"Never be discouraged by failures," continued Madam Chong. "Be brave to defy the odds because God gives us an opportunity to start everything anew each and every day."

"Thank you for your encouragement," I said, feeling moisture coming to my eyes, as I reflected on my first day as a teacher. It wasn't so bad after all. God has given me the strength to carry on through some kind people. Already, I was looking forward to tomorrow.

"Shit!"

Flashes of lightning streaked across the sky. Thunder rumbled like a drum roll in the distance. Dark clouds were gathering; a heavy rain was imminent.

Against a headwind, I weaved hurriedly through a maze of parked cars towards Bank Simpanan Nasional, the place where I receive my monthly salary. Chinese New Year was around the corner, and I needed to withdraw some money for my parents. When I reached the ATM booth outside the building, I looked at my own reflection on the glass wall and tidied up my tousled hair with my fingers. I fished out my card from my wallet and inserted it into the teller machine. A short lady was standing next to me, running her hand over the keyboard of the other machine for seemingly the same reason: to withdraw cash.

As usual, the first thing that flashed on the screen of the machine was the instruction: "Key in your PIN." I did as instructed and pressed Enter. Next, a table of figures ranging from RM100 to RM1000 appeared, and I selected the amount of cash that I wanted to withdraw. The machine whirred strangely, and instead of receiving my money, the screen went pitch black.

I gasped and wondered what was happening. The light returned to the screen in about five seconds along with a statement: "Your card has been retained."

"Shit!" I said.

Exasperated, I cursed so loudly that it startled the lady standing next to me. She cast me an apprehensive look and sidestepped away from me, as if I were a low life or some other social miscreant. Embarrassed, I smacked my forehead and apologized to her. "Sorry, my ATM card has just been swallowed."

She looked at me, her mouth agape. I repeated the apology once more. The tenseness on her face gradually loosened up, and her eyes glinted with amusement.

"Hehe," she giggled, as if the joke was on me. "You'd better claim your card in the bank."

My cheeks continued to burn. After thanking her, I hurried into the bank, hoping that I'd never see her again.

When I got my card back, I went back to the ATM booth and withdrew my money. Suddenly, thunder cracked and dark clouds in the sky spilled their heavy rain. Desperate to get home, I ran across the road to a sundry shop amid the knotted skein of rain. I was filled with relief at the sight of some umbrellas there. I picked a rainbow-coloured umbrella and took it to the cashier counter. Just as I was about to pay the money, I heard a familiar voice behind me. I looked over my shoulder and saw the lady I had met at the ATM booth.

I blushed in embarrassment.

"Did you get your card back?" the lady asked.

"Yes, I did. Thanks for the reminder"

"Getting yourself an umbrella?" she asked, pointing at the umbrella in my hand.

"Yes, it's raining heavily," I said. "Fortunately, the shop sells umbrellas. Otherwise, I may have had to wait till the rain stops."

"I bought myself a new umbrella in this shop, too." The lady shook her umbrella showily, as if she wanted to make a point.

"I guess we are both lucky," she added, and paused as she looked at me again. "Next time be careful with your words. You never know who'll be listening in. You just might bump into them again and wouldn't that be embarrassing?"

Again I blushed, as I watched her open her umbrella and venture into the pouring rain.

Lost in Hangzhou

The moment I discovered I was lost, I knew it was not going to be easy to get back to my hotel through the claustrophobic maze of buildings. It was my second day in Hangzhou, a scenic city famous for its large lake, Xi Hu, which literally means *Western Lake*. Steeped in history, the city is the dwelling place of many renowned scholars in China.

Nine days prior, I had flown to Shanghai from the international airport in Bandar Seri Begawan, Brunei. My tour group had visited Suzhou, Wuxi, and Yangzhou before setting foot in Hangzhou. The name of our group was *Halim,* a well-reputed travel agency in Miri, Sarawak. It was my first trip to China, and I was excited beyond measure. After dinner, I decided to venture around the city on my own. Fringed with dripping willow trees, the city was beautifully iluminated by colourful lights. Everywhere I went, old and new shops arranged themselves in serried ranks. After a few minutes, I came to a cluster of stalls where bric-a-bracs and ceramic vases were sold. Not interested in them, I kept going. Later, I retraced my steps as I attempted to make my way back to the hotel. Then, I realized

that I could not remember which alley I had exited. I entered one only to discover that it forked out into many streets. I backtracked and walked into another street that seemed to have no end. I could not recognize any of the buildings, the shops all looked the same.

In the grip of panic, I wandered around aimlessly. Fear had gotten a hold of me. I tightened the collar of my jacket around my neck as protection against the biting chill. It was now early winter, and the air was particularly cold at night. White vapours rose from my mouth as I breathed. Despite the late hour, the crowds along the street never seemed to recede. *What should I do to get help?* At that very moment, a tiny voice in my head spoke to me: *Why don't you take a taxi back to your hotel?* From the chaos of my mind, the question jerked me into sanity. I looked around and saw a taxi coursing along the street. Just as I was about to flag it down, I realized that I had forgotten the name of my hotel. Worse still, my cell phone was not in my trouser pocket. I could not phone any of my fellow tour-mates. *I must have carelessly left it on my bed at the hotel.*

In dismay, I plodded along the street. Shrill, mournful opera music from a nearby sundry shop rent the cool night air. I felt like crying. *Why am I so stupid and careless? Why did I leave the comfort of my hotel room and subject myself to such a torment outside? Is my roommate looking for me?* I desperately missed the security offered by his companionship.

My aimless walk eventually took me to the warmth of a restaurant. I sat down at a small table and ordered a pot of tea. I sipped the liquid quietly, having no idea how it tasted. My brows were closely knitted, and my hands clenched tightly around my cup. The restaurant was full of rapid-fire chatter. Most customers were smoking. Their loudness confounded me.

My solitude captured the interest of a waiter. He came over to my table and asked me in a polite voice, "Sir, you don't look like a local. Where are you from?"

I looked at him timidly, my mind too blank to answer.

"Are you from Gwangzhou?" persisted the waiter, determined not to give up on engaging me in a conversation.

Remembering Mama's advice, I resisted my impulse to say no. She told me that it would be safer to let strangers in China assume that I was a local than to admit that I was a Malaysian tourist. Many Malaysian solo tourists fell victim to local scammers in China.

"Are you from Gwangzhou or Taiwan?" asked the waiter again in a probing manner.

"Gwangzhou," I answered, trying to sound calm and collected. However, the tremor in my voice betrayed me.

"I see. Welcome to Hangzhou," camethe waiter's reply. I could see a sly glint in his eyes. My accent must have given me away.

"Sir, we can recommend some girls for you in case you are lonely," interjected a tall customer who had appeared silently behind me.

Shocked, I shook my head and said that I was not interested. The two men smiled and left me alone. I went on sipping tea from my cup, but my heart beat faster than usual. The brief conversation with the two men made me feel all the more unsafe. I had already lost my way, and now I had become the target of pimps. Although the tall man and the waiter were no longer around me, I could still feel their eyes on me. My skin prickled with fear. The atmosphere of the coffee shop became increasingly suffocating as cigarette fumes permeated the air.

In haste, I paid my bill and left the coffee shop, escaping the fug of its smoke-filled interior and the danger that lurked

within. Once again, I was exposed to the coldness and darkness of the street, which had become much quieter. The number of pedestrians had dwindled to only a few. Quite a number of shops had closed. I felt oppressed by the ominous silence. In my state of anxiety, everything around me looked portentous of evil.

During my mindless walk, I chanced upon a broad road. A few men were drinking beer under a poplar tree at the mouth of the road. I sidled past the group, hoping that none of them would accost me. I quickened my pace and crossed the road. I found myself in a brightly lit area. Another hour had passed; it was now ten o'clock at night and I still hadn't the slightest idea where I was. I sighed and ridiculed myself for my misfortune. *I may have to sleep on the street tonight*, I thought.

Suddenly, I caught sight of two familiar figures in a shop that sold tea leaves. They looked like my tour-mates. I walked nearer to the shop to confirm that my eyes were not playing tricks on me. Indeed, I knew them! With great relief, I walked into the shop and greeted them. My eyes felt moist and warm.

"Mr Lo, what a surprise to see you here!" exclaimed one of the ladies.

"Indeed, I was around sightseeing," I lied, not wanting them to know that I was lost.

"We are planning to go back to the hotel now. Care to join us?" asked the other lady.

"Yeah, I am getting sleepy," I said, keeping my excitement in check.

I let them walk ahead of me, and pretended to be their bodyguard. After ten minutes, the familiar facade of our hotel came into view. They thanked me for accompanying them, but it was I who wanted to thank them for leading me back to the hotel.

My Struggle with Panic Attacks

I do not know how it all begins. Out of the blue, a dreadful, churning nausea wells up in me. The air around me seems to become toxic, and I cannot breathe properly. My chest and throat feel dry and tight, as if constricted by a snake. Tiny balls of light flash before me. *Am I hallucinating?* A powerful surge of fear washes over me. My hands shake involuntarily. My forehead, armpits, and palms are damp with cold sweat. My heart is throbbing fast, and my head is in a whirl.

Holding my chest in anguish, I plonk myself down on the chair and ask my students to do their own work. The students let out an uproarious cheer. Most of them did not pay attention to my verb conjugation lesson, and they are thrilled to be left to their own devices. The classroom is a cacophony of voices. Nobody pays attention to me. I find myself being gradually sucked into a vortex of emotions. I am trying to fight off a strong urge to cry. With all my might, I clench my fists . . . but it does not alleviate my feelings of dread.

I have been depressed for the past few months. I am struggling with a newly assigned job, which was foisted on me. I have to stay up late almost every night to do my paperwork. I want to seek help from my colleagues, but fear that they will ridicule me. I also have another problem: I'm worried about my chances of getting a promotion. Being the lowest-ranked teacher at my school, I am desperate to end my state of abject humiliation. I applied to the Education Department for the promotion last year, but have received no reply. Day in and day out, I wait for the letter in vain and wallow in self-pity. I never expected that my stress would rise uncontrollably to the surface today.

When my lesson is over, I teeter back to the staffroom like a drunkard. My head is light, and my steps are doddery. Stuttering, I ask the afternoon senior assistant for permission to go to the hospital. Seeing that I am unwell, she grants my request. I ring up my father and he takes me to the hospital.

While waiting for a doctor to attend to me, I am fighting a futile war against my troubled emotions. My energy is gradually sapped by the debilitating coldness that pulsates through my veins. I even find it difficult to sit upright on the low-backed chair in the waiting hall. My back muscles are sore, and my shoulders shake like leaves. At one point, I experience numbness in the upper right side of my neck. I cannot look sideways for a frightening period of ten to fifteen minutes. *What is wrong with me? Am I suffering from a minor stroke?*

After what seems like an eternity, I am called into the consultation room.

"What is your problem, Mr Lo?" asks the doctor.

I want to tell him how unwell I am, but words elude me. I am too overwhelmed by the onslaught of my emotions. The

doctor puts his hand on my shoulder and asks me to inhale deeply before speaking. I follow his instructions, and in disconnected sentences, I manage to tell him about what I have been going through. Each time I flounder for the right words to get my message across, he smiles at me encouragingly.

"You are under tremendous stress, and you need to relax," says the doctor.

"Do I have a heart problem? My heartbeat is fast," I ask in a voice laced with worry.

"I am going to give you an injection to calm you down. A nurse will monitor your heartbeat," the doctor gently replies.

The doctor gets up from his seat and gives me the so-called nerve-calming injection. I grimace in pain as the needle pokes the muscle of my upper arm. And then a male nurse takes me to an emergency ward and asks me to lie down on a narrow bed.

"Take your shirt off," instructs the male nurse.

I do as instructed and lie down on the uncomfortable bed. He rubs some ointment on my chest and pastes the long electrode plugs of an electrocardiogram on my chest. He turns the machine on, and I watch the reading of my heartbeat being printed on a long piece of paper. While waiting for the result, another nurse comes and takes my blood sample. She tells me that the doctor wants to see whether my blood glucose level is within the normal range.

"What has it got to do with my rapid heartbeat?" I ask in bewilderment.

The nurse smiles and says, "It's part of the procedure. Be patient."

The two tests are able to temporarily distract me from my suffering. When I return to the waiting hall, Papa asks whether I am hungry, and I shake my head. He is hungry and decides to

have dinner at the hospital canteen. During his absence, I am seized by a sudden urge to retch. I rush to the toilet and vomit some watery liquid. I look at myself in the mirror and find my face drained of colour. My eyes are bloodshot, and my hair is a rumpled mess. On my way back to the waiting hall, I lose the swinging rhythm of my arms for no reason at all. I groan and cross my arms as hard as I can. My tinnitus-affected right ear rings louder than usual. I make a soundless cry to God: *Lord, drive the devil out of me. I can't stand it any more! My mouth is dry and bitter. Is this the taste of depression?*

After twenty minutes, I am called back into the same consultation room. The doctor pronounces that I am all right. He advises me to take a good rest and forget about my troubles. I reach home at almost eight in the evening. Papa cooks some porridge and insists that I eat it. I can only eat a morsel, and I go to sleep after having a hot shower. However, I can't drift off into a peaceful slumber. My suffocating workload and my failure to get promoted come back to haunt me again. A numbing sensation keeps coursing through my arms. I can also feel a great weight settle on my forehead. The more I want to shut my eyes, the heavier the weight becomes. The walls of my bedroom seem to be closing in around me. I want to shout, but no voice comes out. My consciousness slowly fizzles out into nothingness. *Am I dead?*

I wake up the next morning feeling emotionally drained. Worse still, my bed is wet with urine, and I am filled with shame. Papa has to wash the mattress and dry it in the sun. I do not go to school that afternoon. I am both physically and mentally unfit to teach.

From June to July, I have regular bouts of panic attacks. I make countless trips to the hospital. As a result, I am absent from

school for a staggering thirteen days, and many of my colleagues gripe about having to sit in for my lessons.

One rainy day, I am having another panic attack. I am moaning and trembling in bed when Ah Hui, my eldest sister, rushes into my room and says, "Tai-Tai, you can't go on like this forever. You have to find a different approach to dealing with your problems!"

In a trembling voice, I say, "I can't handle my newly assigned job well. There's no one helping me. The deadline for my report has dwindled to fourteen days, but I have only finished 40 percent of it."

"Why don't you seek advice from the head of your department?" asks Ah Hui.

"No, I dare not," I say. "She might label me as useless and incompetent."

Ah Hui furrows her eyebrows and replies, "Don't be negative. Haven't you noticed that you are making yourself miserable with your pessimism? Don't keep everything to yourself."

Saying nothing, I dissolve into tears.

"If you are too scared to get help," Ah Hui hisses, "I will go to your school and ask your head of department to appoint someone to help you."

Jerking up from my bed in shock, I say, "No, don't do it. I will try my best to get help."

Ah Hui smiles and says, "Make sure you do. As for your promotion, wait patiently for the reply. Telephone the national education commission if you are eager to know the result of your application."

My sister's words knock some sense into my head. When I return to school the next day, I embolden myself to discuss my problems with the head of my department. To my surprise, she

listens with concern and agrees to appoint someone to help me. I feel very much relieved when the appointed person comes and takes some files from me. Later in the afternoon, I telephone the national education commission and enquire about my chances of getting a promotion. To my delight, the officer tells me that my application is being reviewed. From that day onward, my condition improves.

At the urging of Papa, I go to China on a nine day tour to relax my mind. I enjoy the year-end trip very much. It takes a huge load of stress off my shoulders. When I return to Miri, I no longer experience panic attacks.

The terrifying experience has taught me the importance of talking out my problems with others. I could have been spared the horrors of panic attacks had I handled my problems positively. I hope I will never be beset by panic attacks again. I've learnt my lesson the hard way, an ordeal I never want to repeat for the rest of my life.

Reading

One day, I was talking about books with two friends, an Indian man named Gopal and a Chinese woman named Jamie.

"What books did you read as a kid?" Gopal asked me.

"My English proficiency was quite low then," I answered. "I read a lot of Chinese novels. I would only read English novels when I was in the mood. My favourite was the Famous Five series."

"I read the Famous Five series as well," said Gopal. "I was also a staunch fan of Nancy Drew and the Hardy Boys. When I was a secondary school student, I graduated to reading classics."

"Me too," said Jamie. "As a child, I had strong foundations in both English and Chinese. I read the classics of both languages."

"How impressive!" I replied. I could not praise them enough.

"Have you ever read classics?" asked Jamie.

"Yes, but only recently," I replied.

"My goodness," Gopal exclaimed, "I have read so many classics that I don't wish to see any of them now!"

"You've missed too much, Lo," said Jamie.

Shrugging my shoulders, I said, "I don't find it too late. Reading books like *Jane Eyre* and *Passage to India* gives me aesthetic enjoyment."

"I read *Jane Eyre* when I was thirteen," said Gopal, his voice tinged with pride.

"I read *Passage to India* when I was fifteen," Jamie said smugly.

"Did your parents encourage you to read English books?" asked Gopal.

"They did. They always encouraged me to borrow books from libraries," I replied.

"My parents were both professionals. They made sure I wrote a book report on any book I read," said Jamie.

"My parents asked me to talk about my feelings after reading a book," said Gopal.

"My parents would be happy if I could finish reading a book. They never thought of asking me to write a book report," I said.

"My parents were different. They were concerned about my language development," said Gopal.

"My parents took my reading hobby seriously. It was no child's play to them," said Jamie.

"How long does it take you to finish a book?" I asked the two friends.

"One to three days, depending on what book I read."

"Two to four days. I read almost every day."

"What about you, Lo?" asked Jamie.

"I am a slow reader. It takes me one to four weeks to finish a book."

"I can't believe it!" Gopal blurted out incredulously.

"My fourteen-year-old son could easily beat you with his reading speed!" said Jamie.

"What makes you so slow at reading?" asked Gopal.

"I look up difficult words in my dictionary and copy interesting words and phrases," I answered.

Jamie clucked her tongue and said, "I think you are not used to reading books. The way you read deprives you of reading pleasures."

Gopal nodded in agreement and said, "The more you read, the faster your reading speed becomes."

"Regular reading enables you to guess the meanings of words correctly from the context without referring to dictionaries," remarked Jamie.

"I am too used to my reading habit, and I find nothing wrong with it," I said. "Can you remember new words well?"

Jamie smiled and said, "I can remember every new word well. My mind is like a photocopy machine."

"I have a knack for remembering new words," said Gopal. "They will never slip my mind."

"You two are simply amazing!" I said, looking at them with wide eyes, though I didn't believe half of what they said. Then again, maybe I needed to step up my reading habit and devour books in the same way they do.

Advanced Vocabulary

One day, I asked an elderly colleague whether I could read her students' essays. She shook her head and told me that she did not have their writings with her.

"It's okay," I said. "I can read their essays the next time they hand in their exercise books to you."

"Are you sure you want to read their essays?" she asked, sounding somewhat incredulous.

"Yes," I replied. "They are the best students in secondary two. I am sure their writings are impressive."

She paused for a while and said, "You're right. They are the cream of the crop. They have an edge over other students in writing."

"I am sure that is because of your proper guidance."

"Of course, I have always shown them good writing techniques."

"I could hardly construct simple sentences when I was fourteen years old," I said. "They must have read a lot of books."

"I am an avid reader myself," declared the woman, "and I am sure you read very little as a child."

"Yeah, I read very little," I admitted, "but my interest in reading grew when I was seventeen. Reading helped me to improve my English."

"Continue doing that. You should never stop."

I became a little uneasy by the tone of her remark and declared, "I've never stopped."

She smiled and glanced at her watch before saying, "Mr Lo, I have to go to my class now. Talk to you later." She slung her small handbag over her shoulder.

"Remember to show me your students' writings," I said.

"I will," she said, "but I doubt if you will be able to understand their work. Their writings are full of advanced vocabulary."

I was shocked by her presumptiousness.

"What do you mean, Miss Cathy?" I blurted out, feeling hurt.

She gave me a holier-than-thou look and strutted out of the staffroom. She never did show me those essays. I wonder what she was hiding.

Madam Sheila

In my life, I have never seen an English lecturer as strict and hardworking as Madam Sheila Chai.

When she was teaching, her smile eluded her. She was austere and rigid. Nothing could escape her all-knowing, penetrating eyes. She spoke with full authority. Each word she uttered rang like a decree; nobody dared to mess with her. She could detect any lapse of attention like a bloodhound. Making grammatical errors was a mortal sin to her. She could not tolerate a teacher in the making committing such an offence. Hence, my classmates and I were constantly scolded for our error-riddled writings. To improve our English, she drummed the rules of grammar into our heads. She took great pains to read and edit every part of our assignments before returning them to us. Her tireless efforts were fruitful. After doing tons and tons of corrections, we became more confident about our writing.

The following are some of the things she used to say when scolding us:

- "I don't expect you to like me. I bark at you because I care about your well-being."
- "I am a person of high standards. I see your grammatical errors as a disgrace to the teaching profession. Read more to improve your English!"
- "Don't look at me with your sour, tired faces. Teachers must be high-spirited and proactive."
- "Never expect me to be lenient with you. Only strict teachers can produce quality students."
- "You are not half as good as my ten-year-old daughter."

The remarks were biting. But I remember them all my life. They make me more determined to improve my English.

Many trainee teachers cried at her farewell party. She hugged many students and pecked their cheeks lovingly, like a mother. Because of my shyness, I neither hugged her nor shook her hand. I did not even say thank you to her. But I never forget her and her helpful lessons.

I am not sure whether Madam Sheila is still teaching, but she must be in her early sixties now. I found her picture on Facebook last week, and I think the two kids on her lap in her profile photograph must be her grandchildren. I sent her a friend request so I could have the opportunity to thank Madam Sheila for everything she has done for me. Without her, I wouldn't be who I am today, a teacher committed to learning and teaching my students how to write grammatically correct sentences. I am sure she would be proud of me.

A Visit to The Bangkita Tamu in Limbang

"Encik[5], all my ferntops are freshly picked. One bunch, one ringgit."

"Taukeh[6], my catfish are fat and succulent. They are very delicious."

[5] Sir(Malay)
[6] Boss(Hokkien)

"My snake fruits are sweet and crunchy. One kilo, only four ringgit."

At nine o'clock in the morning, the sun was already high above the horizon. Ng, Robin, and I were weaving our way through thick crowds of bargain hunters. On both sides of us, vegetables, fruit, and fish were heaped like miniature mountains on newspapers and tarpaulin sheets. Everywhere we went, friendly vendors tried to persuade us to buy from them in Brunei Malay.

"The language similarity is due to Limbang's close proximity to Brunei," I explained to Ng, a teacher from West Malaysia. We were busy comparing prices in our minds as we feasted our eyes on the kaleidoscopic display of local produce.

A basketful of plants with red, knobby roots caught Ng's eye. He squatted down on his hams and asked the middle-aged male vendor what they were.

"They are red turmeric," replied the vendor.

"Red turmeric," Ng gasped, "Can they be eaten?"

"Of course," said the vendor. "They can also be made into a lotion."

He gestured towards a small cluster of bottles. "I made the lotion a few days ago. It is good for relieving rheumatic pain."

Ng picked up a bottle and shook it. The liquid foamed and imparted an oily sheen. He uncapped the bottle and sniffed its contents. "The smell is strong and pungent," Ng commented to me in Chinese. "I am sure alcohol was used in processing the lotion, together with some oil."

"Want to try it?" asked the vendor, his voice full of expectation. "It's only eight ringgit."

Ng shook his head and walked away with Robin. The vendor smiled good-naturedly and rearranged the bottles.

Two men stopped by the same stall and looked at the bottles intently. The vendor greeted them politely, and they began the ritual of haggling in a local patois that sounded like Bisayah. A deal seemed to be struck, and the vendor put a few bottles in two plastic bags. The two customers grabbed the bags of bottles and disappeared into the crowds. The vendor's beaming face revealed his gratefulness. In this era of modernization, there were still some people who believed in the healing effects of traditional medicine. I respected the vendor because he was one of the few people in our country trying to keep the dying art of making traditional medicine alive.

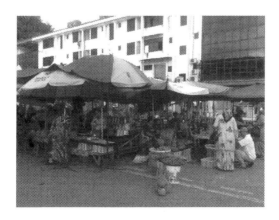

This was our last day in Limbang. Ng, Robin, and I had come from Miri for the state-level Scrabble competition in SMK Kubong. Luck eluded our team. We crashed out in the preliminary rounds, but we did not want to leave Limbang empty-handed. We wanted to buy as many goodies as possible in the Bangkita Tamu before returning to Miri. The Bangkita Tamu is one of the major tourist attractions in Limbang, an open-air market where you can see a motley assortment of goods. Every Friday and Saturday, from approximately five o'clock in the morning to six o'clock in the evening, it takes place in the car park between the land transport department and the national accountancy department. The stalls, mostly covered by large parasols, spread westward to the front of a shop lot that houses the Avon cosmetic boutique and the Kentucky fast-food restaurant. Most locals do their weekly marketing there. It is also the regular haunt of Bruneians. The Tamu thrives because of the Bruneians' superior purchasing power.

I hastened my steps and caught up with my two friends, who were already carrying a few plastic bags of vegetables in their hands. They stood at a stall that sold *Ikan Tahai* (small, smoked fish), a unique product found only in Limbang, Lawas,

and Brunei. There were two types of *Tahai* fish, the traditional, plain-smoked ones and the ones coated with chilies. The vendor, a young Malay in his early twenties, gave us a few samples of both to try. They were crispy and savoury, but I especially liked the plain smoked ones because their flavour was more intense. Although the other ones were coated with chili powder, they were more on the sweet side.

"How much is one kilo of *Tahai* fish?" asked Robin.

"It's ten ringgit," replied the young vendor.

"Give me one kilo of plain *Ikan Tahai,*" said Robin, "and one kilo of the ones with chilies."

"I also want the same amount of *Ikan Tahai,*" said Ng.

"I want the plain ones," I said.

The vendor took a piece of brown paper and folded it into a cone. Next, he cut off the v-shaped bottom of the cone with a pair of scissors. And then he put a large plastic bag into a container, grabbed a few handfuls of *Tahai* fish from a large pot, and filled a plastic bag with them through the funnel-like cone until it was full. After that, he put the plastic bag of *Tahai* fish on a scale, and the reading was exactly one kilogram. His accuracy bowled us over, and we gave him a clap. He smiled and repeated the same procedure for the other bags of *Tahai* fish. Our plastic bags bulged with a large amount of smoked fish. A lot of Bruneian tourists bought the fish too. In Brunei, it is not possible to get that many fish at such a good price. No wonder Bruneian tourists like buying lots of them to take back home. A trip to Limbang would not be complete without the purchase of them.

"The locals like to cook them with *Terung Assam,* a kind of sour eggplant that is yellow," said the young vendor. "The smokiness of the fish and the sourness of the eggplants really whet one's appetite."

117

Our next stop was a stall that sold bamboo shoots. There were two young girls manning the stall. In front of them were several plastic bags of bamboo shoots that had been cut into strips. Beside them was a small heap of cone-shaped bamboo shoots that had not been cut.

"How much is one plastic bag of bamboo shoots?" I asked.

"Four ringgit," answered the older girl, showing her white, toothy smile.

"I want to ask my wife to cut the bamboo shoots herself," said Robin. "Give me three bamboo shoots."

"I want two plastic bags of bamboo shoots," I said.

"Okay," said the older girl. She handed me two plastic bags of bamboo shoot strips, and I paid her eight ringgit. The younger girl gave Robin three whole bamboo shoots and received twelve ringgit from him.

Ng looked at the heap of bamboo shoots with interest and asked the younger girl, "Can you show me how to cut a bamboo shoot?"

"No problem," said the girl. She grabbed a whole bamboo shoot and made a thin cut across its shelled body. She then drove the sharp tip of her knife into the slit.

"Slide the knife under the shell in a clockwise direction," said the girl. "It will come off easily."

"How skilful you are," said Ng as he saw the girl throw the discarded shell into a bin.

"Can you see the white pulp between the top and the bottom?" asked the girl.

"Yes, it looks so tender," said Ng.

"Only the white pulp is edible," the girl said as she cut off the top and the bottom parts.

"Why?" Ng asked curiously.

"The other parts are too chewy," explained the girl.

"I see," said Ng.

The girl put the pulp upright on a chopping board and cut it into halves. And then she deftly cut them into strips and rinsed them in a basin of water. Having done that, she put all of them in a plastic bag and said, "That's all. Very simple."

"Thanks for demonstrating how to cut it," said Ng. "I'll take the bag of bamboo shoot strips."

"Thanks," said the girl. "It's four ringgit."

"Give me two whole bamboo shoots, too," said Ng. "I want to cut them at home."

"All right," chirped the girl.

Ng paid the girl the money and left the stall with us, his face glowing with childlike thrill.

"You seem to very pleased," Robin observed.

"Yes, I am," said Ng. "The girls are very friendly."

Ng was right. Most of the vendors in the Tamu were not only friendly, but also willing to share what they knew with you. They made the Tamu sizzle with goodwill—unlike the sales assistants in supermarkets who always seem bored and reluctant to help.

I bought two stalks of bitter mustard greens from an elderly lady, and she gave me a useful tip for cooking them.

"Do not add salt to the mustard greens when you fry them," said the lady.

"May I know why?" I asked.

"Salt will make them more bitter," said the old lady, grinning. "Fry them with dried anchovies."

"Thanks for your suggestion," I said, glad to have gained some new knowledge today.

The Bangkita Tamu had a lot of surprises in store for us. Where else could we see so many vegetables, fruits, and other products not commonly found in ordinary markets? Take the bitter mustard greens, for example. Unlike ordinary mustard greens, their stalks are slimmer and their leaves serrated, narrower, and less crinkled. They have a natural peppery taste, which is delicious. I also came across *ding,* a type of magenta shelled fruit that is said to be a good cure for high blood pressure. Its pulp is also magenta in colour, and it contains many tiny, edible seeds. Robin bought a packet of river fish, which are slightly smaller than anchovies. The lady vendor who sold the fish called them *sada riyao.* She told Robin that the best way to cook them was to deep fry them.

"The fish can also be made into fermented fish," she added.

A mischievous vendor asked me to try some *sago* worms, but I dared not eat them. They looked so cute and pitiful.

Robin had a heated though good-natured negotiation with an elderly vendor over the price of a *parang*. Their noise attracted a crowd of people. The elderly vendor insisted on selling it at seventy-five ringgit, but Robin wanted it at thirty-five ringgit. The old man was firm in his decision, and he wouldn't reduce the price. After ten minutes of argument, the old man finally relented and said, "Okay, I will sell it to you at sixty ringgit."

"What about thirty-five ringgit?" Robin suggested, still being stubborn.

"I refuse to sell at thirty-five ringgit," the old man fumed. "My capital was even more than that."

"Why?" asked Robin with a flippant smile. "My father-in-law is an aficionado of *parang* knives. He will be glad if I give him the knife. You will get thousands of blessings for selling it to me."

"If you want to do something good for your father-in law," retorted the old man, "buy the knife at sixty ringgit in appreciation of my hard work. It was not easy for a seventy-four-year-old man like me to solder this knife."

The old man's rejoinder made Robin blush. The school headmaster agreed to take the *parang* at sixty ringgit. He exchanged hugs with the old man, and the surrounding people cheered. Ng and I could not help smiling.

We bought many more things in the Tamu, but the combined cost of Ng's and my goods hardly came up to one-third of what Robin had bought. We had to help him carry a box of crabs and two gunnysacks of red rice. After two hours of marketing, we decided to call it a day and filled Robin's car boot with our purchases.

"Lo, are you happy with what you bought?" asked Robin.

"Yes, I am," I said, looking forward to my dinner.

"The trip's been an eye-opener," Ng chimed in. "As a townie, I have never seen so many fascinating things."

Robin started the motor, and we left the Tamu. In four hours, we would reach Miri through the territories of Brunei.

Already, I was making plans to come back to Limbang to visit the Bangkita Tamu. It beckoned me with its simplicity, its myriad goods, and its friendly vendors.

Pak Pandir

Recently, I attended a course on how to teach literature to secondary school students. The invited speaker was a large Malay man who had once been featured in an American education magazine. He taught us many things through activities such as jigsaw reading, poster drawing, poetry writing and singing.

On the final day of the course, the speaker showed us how to use miming as a means of familiarizing the students with different characters in novels and short stories.

Six teachers were randomly selected to take part in this activity. I was shocked when the speaker announced that Mr. Tay, my colleague, would be the sixth person to perform in the skit. For Mr. Tay, it was not an honour but a disgrace. He had never acted in front of anyone before.

The speaker gave each of them a card. I happened to glimpse Mr. Tay's card and the name on it was Pak Pandir, a funny character who is the Malay version of Mr Bean. Pak Pandir epitomizes the most absurd and outrageous things in the world. *Why did the speaker ask Mr. Tay to mime this silly character?* It

could lighten him up a bit but I could feel the blood draining from his face.

"Ladies and gentlemen," announced the speaker in a deep voice, "those holding the cards have eight minutes to think about how to mime their characters. When the time is over, each of them will act in front of you, and you have to guess which character he or she is miming."

Tay, how privileged you are," said one teacher before nudging him with his elbow.

"You have been quiet throughout the course. Finally, we are able to see you act," chirped a young female teacher.

He could only answer them with a wry, bitter smile.

As a quiet, introverted person, Mr. Tay seemed to find it too humiliating to bring the character to life through silly gestures. He told me that he did not want to become a laughing stock. He was beside himself with fear and panic!

Soon, the miming show began. The first five teachers presented their roles with no problem. They sent everyone into fits of laughter with their actions. I could not imagine Mr. Tay acting like a fool as they had: crying like a baby, sashaying around like a proud and evil queen, hobbling sideways like a crab, loping like a buck, and lumbering like the Hunchback of Notre Dame. When it was Mr. Tay's turn, everyone grinned at him, expecting him to make a fool of himself in front of them. Their stares petrified him. He stood motionless at the centre of the room.

"C'mon, Tay, start miming now," prompted the speaker.

"I can't," said Mr. Tay, looking pleadingly at the man. "I don't know how to delve into my character."

"I have given you eight minutes to think about how to act. I'm sure you can do it," said the speaker, oblivious to the mercy-seeking expression on my face. "Unleash your inner talent now."

"I can't," he replied. "I don't know the character on my card well."

"Are you sure?" asked the speaker, looking at him in disbelief.

"Yes, I am!" Mr. Tay said, trying to sound firm. I knew that his reason was not convincing. Pak Pandir is a household name in Malaysia.

"Don't chicken out, Tay," persuaded the speaker. "Teachers are supposed to be good actors."

Sensing that the speaker was actually taunting him, Mr. Tay said adamantly, "I really can't do it. I mean what I say."

Every participant in the room fell silent. The speaker stared at Mr. Tay for a few seconds and said, "Okay, you may go back to your seat now. Give me your card."

Mr. Tay gave him the card and returned to his seat. Dozens of eyes were following him. He tried to feign an air of nonchalance.

"Okay, everyone," the speaker said in a raised voice, "I will act on Tay's behalf. Sometimes we need to offer someone a helping hand."

With that, he started his miming. He cocked his head jerkily from left to right and put an imaginary hat on his head. Then, he acted as if he had tripped over something and fell. He struggled up comically and pretended to pick up a stone before tossing it into what seemed like an imaginary sea. Every teacher except Mr. Tay laughed and clapped his or her hands. A few female teachers doubled over with laughter. When he had finished, he bowed chivalrously.

"Who am I," asked the speaker.

"You are Pak Pandir!" shouted one lady.

"What genius acting!" shouted another lady in a voice full of admiration.

The speaker looked very pleased and bowed a few more times. The room was filled with cheers and clapping, and he soaked up the adulation smugly.

"Ladies and gentlemen," said the speaker, "what is the moral of this activity?"

"Be confident when assuming new roles and responsibilities," opined a lady.

"Yes," said the speaker, "we can teach our students to be positive when taking up new roles. What else?"

"We can help uncover hidden talents. Our students will become more creative," said a male teacher.

"You're right," said the speaker. "We can help our students tap into their creativity."

"I like what we did just now. It encourages mutual learning. I am sure my students will enjoy it," remarked another teacher.

"Yes," said the speaker, "the activity enables the students to identify the personality traits of different characters in literary texts. As a teacher, you should tailor your activities in such a way that they are student-centred. To make the students grasp the concept of your teaching, you have to act first. Remember: do not let your character confine your creativity. As the forerunners of education, we should be proactive, innovative, resourceful, and brave when facing challenges."

The course came to an end on a high note. Many participants shook hands with the speaker. Mr. Tay did not shake hands with the man because he was not happy with what he had said in his closing speech. He seemed to be hinting that Mr. Tay was not positive enough.

It's true, I thought. *Mr. Tay is always too negative. Everyone saw it except him.*

Stereotypes

I woke up at four o'clock in the morning to an extreme itch all over my body. I was in Penang, inside my hotel room. I had indulged in a seafood buffet with my friends the evening before, so I assumed it was the shellfish causing an allergic reaction. I had no time to see a doctor because I had to take a flight to Kuala Lumpur at seven o'clock.

As soon as I reached Kuala Lumpur, I searched all over the vicinity of my hotel for a clinic, but I couldn't find one open since Saturday is a rest day for most clinics in the city. I rang my younger brother, but we could not meet because of scheduling conflicts. Finally, I hailed a taxi, and the driver agreed to take me to a twenty-four-hour clinic that was very far from my hotel.

On the way to the clinic, the driver asked me, "Sir, do you have any problem with your *lampa?*" He was talking about my penis!

Shocked and embarassed, I said, "No, I have an allergic reaction!"

The driver chuckled and said, "I'm sorry, but most of my customers have such a problem. All because of their one-night stands."

"I am not like them!" I said curtly. *He shouldn't have pigeonholed me like that,* I thought.

But there was another reason I overreacted to the word *lampa*. Due to the allergic reaction, there were rashes on my scrotum.

"Sir, you are dark and big. Are you a labourer?" asked the driver, changing the topic.

"No, I am not," I said, keeping my frustration in check.

"What are you, then?" asked the driver, inquisitive as ever, insolent too.

"I am a teacher," I answered.

"Sorry for having a wrong perception of you," apologized the driver, "but you don't have the polished look of a teacher."

"I don't fit into the stereotypes," I said sarcastically.

We reached the clinic in thirty minutes. I went in and registered at the counter. After a few minutes of waiting, I was called into a consultation room. The doctor was a young Malay man dressed in a grey T-shirt and a pair of jeans. I wondered where his white uniform was.

"What can I help you with, Mr Lo?" asked the doctor.

"I have an allergic reaction, and my body is itchy," I said.

"Where are the affected areas?"

"My chest, my armpits, and my . . . s-scrotum," I stammered.

"Can you take off your clothes and lie down there?" said the doctor, indicating the bed not far from his table.

I took off my clothes and lay down on the bed. The doctor put on a pair of gloves and palpated different parts of my body.

"Mr Lo, take off your underpants. I want to examine your scrotum," the doctor commanded.

My face grew hot and red. Reluctantly, I divested myself of the last piece of clothing, and my private parts were exposed to the eyes of the doctor.

The doctor looked at my male package without expression. He gave it a thorough examination, unfolding the foreskin to check the redness. After a few seconds, he said, "It appears swollen. Is it itchy and painful?"

"Yes," I said shyly.

"Do you experience pain while urinating?"

"No," I said and shook my head.

With that, the examination came to an end as he confirmed that seafood was the cause of my allergic reaction. The consultation cost me thirty-nine ringgit.

The taxi driver gave me a wide grin when he saw me coming out of the clinic.

"What did the doctor say about your *lampa?*" he asked in a ribald tone of voice.

I glared at him and said, "Nonsense! I have an allergy rash!"

The driver was partially right, but there was no need to tell him the truth.

I sighed in relief when the taxi reached my hotel. He charged me sixty ringgit—twenty ringgit for taking me to the clinic, twenty ringgit for waiting for me, and twenty ringgit for taking me back to my hotel. Under the circumstances, I found the fare rather reasonable. Other drivers would have charged me over a hundred.

As I climbed out of the taxi, I thanked the driver for his help and patience. He smiled and said, "It's all right. Take care of your *lampa.*"

I almost choked with anger.

Papa, You Are My Everything

My papa is special.

Every day, around half past five in the morning, the familiar, low, droning cadence of his Toyota Starlet approaches my house. When the beater sputters to a stop in front of my gate, I get into the car.

Our usual conversation on the way to the school where I teach goes something like this:

"Did you have a good night's sleep, Tai-Tai?" asks Papa.

"Yes, Papa," I answer, yawning.

"Where would you like to have breakfast?"

"At our usual place, the 2020 Cafe," I perfunctorily reply.

"Will you be having an extra class this afternoon?"

"Yes, from two to three o'clock."

"I will come and pick you up at three."

"You don't have to, Pa. I can go back by bus."

"It's difficult catching a bus, Tai. Only one bus runs along the Tanjong Road every hour. Just wait for me to take you home," insists Papa.

"Thank you, Papa," I reply. I cannot help grinning. Papa will once again spare me the inconvenience of having to go home by bus.

Papa is the epitome of Doraemon. His invincible gadgets are his unequalled love and care for me. I always go to him for help and support. Every day, he drives me to work without fail. He is constantly worried about my poor health and mood swings. Every two weeks, he takes me to the hospital for my bipolar injection. He will wait patiently in the car park while I am being injected. When I gripe and grumble, he becomes my faithful listener. When I am downcast, he cheers me up by taking me for a car ride around town. He cooks anything I want to satisfy my hard-to-please palate.

Many people say that I look like Papa. I am a broad-shouldered and large-bellied man, and I am also soft-spoken like him. We share a common interest in art and classic Chinese music. We both are loud snorers, too. My sister likes telling me that the sound of our snoring together could tear down a roof. I guess sons usually take after their fathers in many ways. No matter how hard you want to be different, you will end up discovering that you behave and think the same way your father does. The outcome can sometimes be paradoxical.

Papa used to be a moody, churlish person. He could not get over the pain of his bankruptcy in the late 1970s. Many of our friends and relatives treated him with scorn and contempt. To support our family, he learnt how to make steamed Chinese buns and sold them at the night market. Whenever he returned home with a beaming face, I knew that his buns had sold well. If he returned home with a sombre face, my mother would warn my siblings and I not to make him angry. We would watch in silence as he threw all the leftover buns into the garbage. Throughout my

childhood and early adulthood, there was a strong antagonism between Papa and me. I always provoked him—either carelessly or deliberately with my stubbornness, girlishness, and pickiness about food.

One night, my mother dreamt of a choir of angels chanting the verse, "Renounce your old self, renounce your old self." They were repeating the words above a kneeling Papa. The moment she woke up, she could still hear the song until it trailed off into silence.

The day Papa received Christ as his saviour, he became a changed person. He no longer scolded me with harsh words or smacked me with his pain-inflicting palm. He started guiding me with the words of God, and the tension between us gradually eased.

Anywhere Papa goes, he radiates calmness. Despite the fact that he has Parkinson's disease, he refuses to be moody. He also practises an active lifestyle. He believes that he can slow down the progression of the disease by exercising regularly and eating a balanced diet. His left arm no longer shakes as much as before.

One day, a colleague by the name of Lee Kai commented on my attitude towards my father.

"Mr Lo, you are not kind enough to your father," she said.

"What makes you say that? I don't understand," I said.

"Your father is getting old and suffering from Parkinson's disease, and you still ask him to drive you around."

"But I d-don't know how to drive," I stammered, trying to defend myself.

"You should take up driving. He can't be your driver for the rest of his life," she said firmly.

"Lee Kai is right. If you never take up driving, you will be helpless when he is too old to take you around," one male colleague chimed in.

What the two colleagues said struck me like thunder. They were right. Taking up driving would be the first step to breaking my dependence on my father. How beautiful it would be to take my father on a sightseeing tour in my car.

I also took up cooking. Now and then, I will cook for my father. Whether or not my cooking is good, he will eat the food I give him appreciatively.

Papa's hair is all white now. His eyes are surrounded by more and more creases. And yet, I still rely on him. He always comes to my rescue—rain or shine.

Papa, forgive me for giving you so much trouble. I will try my best to stand on my two feet and give you a comfortable life. You are my everything.

Dictionaries

During recess one morning, a boy came up to my desk in the teachers' staffroom.

"Sir," said he, "what should I do to widen my English vocabulary?"

"You should read more books," I replied, smiling. I had been marking exercise books at my desk before the interruption and was glad to have a break.

"Do you still read books, sir?" the boy went on. We were speaking in Chinese. He seemed quite a humble and nice lad.

"Yes, I do. I always read."

"Do you still look up the meanings of words in dictionaries?" he asked again. He was obviously very curious.

"Of course, you should do the same," said I with a sagacious nod.

The boy went silent. He blinked and bit his lower lip.

"What's wrong, Martin?"

He only shook his head and gestured towards the pile of books and dictionaries on my desk.

"Sir, are these all yours?"

"Yes."

A mischievous spark shone in his eyes.

"Sir, I think your English is bad. You depend too much on dictionaries."

"I beg your pardon?!" I could not believe my ears.

"A smart teacher will never refer to dictionaries. I once heard from a teacher that she never referred to dictionaries. You are not as good as I thought."

Obnoxious little toad! I thought

"Martin! You shouldn't be saying such things! To widen our vocabulary, we all need to read and refer to dictionaries in order to better understand how to use new words properly. One will never learn enough English!" I burst out, quite taken aback and shocked at his impertinence.

No reply, only a wide grin at me. Did he understand what was being said, or was he merely pretending to be naive?

"Sir, I would like to go back to my class now. Thank you very much for your advice." Now h*e is all courtesy. Smooth cheek indeed . . . coming from a pint-sized pipsqueak like that!* I thought.

"You're welcome," I said, anxious to be well rid of him so I could return to marking the exercise books.

The student walked out of the staffroom rather gleefully and without a trace of guilt written on his beaming face.

Cheeky little devil!

Acknowledgements

My deepest heartfelt thanks and gratitude to my family, colleagues and close friends whose real life stories have inspired and encouraged me in so many ways. This book would not have been possible without the editing of Robert Raymer, writer of Lovers and Strangers Revisited, Tropical Affairs and Spirit of Malaysia. A big appreciation also goes out to Cousin Tuty Ibrahim for motivating me to read and write.